I CAN DRAW **FAIRIES**

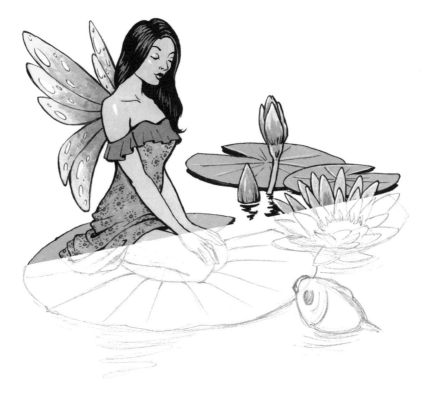

I CAN DRAW **FAIRIES**
STEP-BY-STEP TECHNIQUES, CHARACTERS AND EFFECTS

PETER GRAY

SIRIUS

SIRIUS

This edition published in 2024 by Sirius Publishing, a division of
Arcturus Publishing Limited,
26/27 Bickels Yard, 151–153 Bermondsey Street,
London SE1 3HA

ISBN: 978-1-3988-4494-0
AD011377US

Printed in China

CONTENTS

INTRODUCTION

Fairies, elves, pixies, sprites, goblins, and all their tricksy little friends come to us through centuries of folklore, from all over Europe. We may now think of them as mainly benevolent, playful creatures of fairy tales but different concepts of fairies have existed through the ages. They have been viewed as fallen angels, spirits of the dead, bringers of ill fortune, and otherwise darkly mysterious beings. They have inspired generation after generation of great artists and storytellers, from medieval romances and renaissance plays, right up to the blockbuster fantasy films of the present day.

Through the ages, the ways fairies have been depicted by artists have naturally differed too. For the purposes of this slim volume, however, we will concentrate on the familiar concept of fairy folk as graceful, feminine and essentially human-looking.

Along the way we'll examine various techniques and the use of a range of materials and coloring methods. Art materials can be expensive. It will serve you better to buy a few good quality colors of whatever medium you prefer, rather than buy vast sets of cheap paints and pencils that will only produce insipid, dispiriting results. And remember that color is the cherry on top of the cake; a pleasant and optional extra to the essential practice of drawing.

As the great fantasy character designer, Iain McCaig, says, "Fantasy is just real life with a little twist." All fairy art is based more or less on real people and the real world and thus, in order to draw convincing fairies, we must first be able to draw ordinary people. We'll look at how the head and face are constructed along with characteristic fairy features as well as hairstyles, hats, horns, and headdresses. We will consider the form and proportions of the body, how to pose the figure and clothe it in appropriate fairy fashions, and we'll demonstrate how to set the resulting characters among the flora and fauna of the fairy kingdom.

Keep it in your mind that no one knows what fairies really look like. They are imaginary creatures and just as capable of springing from your imagination as from anyone else's. So don't feel you should copy my demonstrations slavishly; use them as starting points for your own designs. Feel free to explore, experiment, exaggerate, and most of all enjoy yourself whenever you embark on drawing fairies.

How to Use This Book

This book will take you through the process of creating a range of fairies and other fantasy characters and show you how to get them into action. Most drawings are broken down into a series of steps, as set out below.

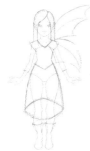

The basic outline of your character.

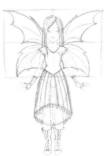

Adding detail to the outline

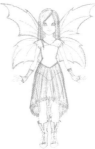

Refining the pencil details before coloring.

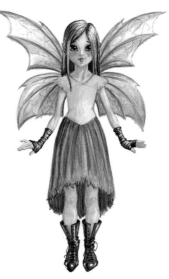

Adding highlights and final details to complete the figure.

Adding initial color to your drawing.

Using ink to sharpen your drawing.

Practice Pages

At the end of most of the exercises, you will find a grid with an outline figure or a space for you to practice your skills. There are also examples of heads and figures for you to trace, copy or photocopy and add in your own details. There are also outlines on which you can practice different color combinations.

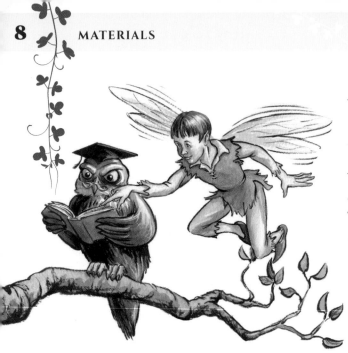

Materials

You don't need lots of expensive equipment to start creating comics. The most important tool is your own imagination!

Just like every other subject, drawing fairies is mostly about drawing. And for drawing we need nothing more than a willingness to apply ourselves to the task and a very few basic bits of kit:

Paper

Most of the pictures in this book were done on basic drawing paper of 120gsm weight. For painting or heavy inking, I'd recommend thicker paper of 180gsm or heavier. (I did all the artwork in this book on A4 paper, but fairies can be fiddly little characters and there's no reason why you should not work larger if it suits you. Just because we think of fairies as small, we need not draw them at scale.)

Scrap paper

For developing characters and compositions, and for testing inks and paints.

Sharpener

To maintain the points of your pencils.

Pencils.

Two or three will suffice, a hard one, say H or 2H for guidelines, and a couple of softer pencils, maybe a B and a 4B for heavier lines and shading. (For the sake of visibility in this book, I have drawn all guidelines and under drawing a lot more heavily than I would recommend. Generally, I suggest drawing them lightly with a hard pencil so that they may be easily and cleanly erased at later stages.)

Eraser

Use a soft rubber or putty eraser to cleanly remove drafting marks that you no longer need.

Color Pencils

A range of color pencils can create different shades and textures on your fairy drawings and have an inherent lightness that suits the subject matter. Some can be mixed with water to make a watercolor effect.

Brushes

Choose your brushes according to your paint medium. Watercolor painting requires soft, supple brushes, while slightly stiffer brushes may be used to add highlights once the initial coloring has been done.

Ink

Inks are used for outlining—you don't just have to use black; it's fine to use other colors. They can also be used for vibrant washes on particular styles of fairy drawing.

Part 1
Fairy Faces
Human Faces

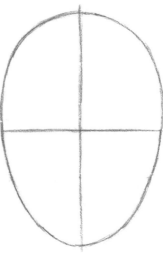

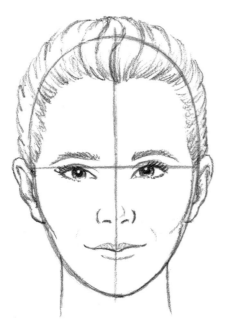

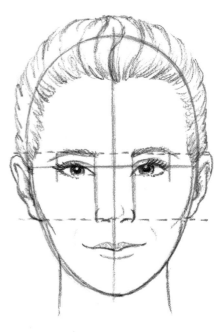

From the front, the head can be seen as an upside-down egg shape, broad and rounded at the top and narrowing towards the bottom. This is the basic shape that artists begin with when drawing a head. Horizontal and vertical center lines are also helpful for arranging the features of the face.

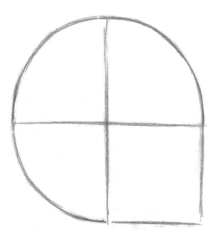

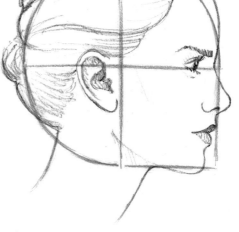

Seen from the side, the head is rather deeper than from the front. We can think of it as basically a circle with a face stuck on the front. You may find it useful to begin your profile drawings with frameworks like this.

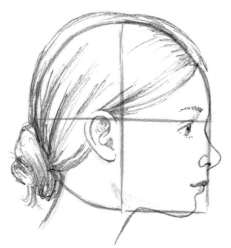

With some features added it's possible to see more clearly how the face fits together. You can see the eye at the half way line, set a little way back from the front of the head and, from this profile view, it's somewhat triangle shaped.

Again, the eyebrow and base of the nose sit on a level with the ear. Note how far back the ear sits on the head–behind the vertical halfway line.

Another surprising thing to notice is that the face occupies such a small area of the overall head, when seen from the side.

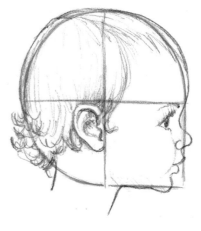

The same head shape can be used for people of different ages, but you need to be aware of the differing proportions of younger faces. Here we see a young girl of about seven and a baby of a few months. Their heads are essentially the same shape, but the faces sit lower on the head, the younger they are. Thus, the girl's eyeline is somewhat lower than the fully-grown woman's, sitting clearly below the center line, and the baby's is lower still.

Noses and mouths are much smaller in younger subjects, but ears and eyes are quite a lot larger, in relation to the overall head size.

Fairy Faces

Many fantasy artists depict fairies with ordinary human faces, although unusually pretty ones. Others draw fairies with distinctive elfin faces. With a general understanding of how to draw human heads and faces, you only need a few adaptations to develop them into fairy-like characterizations. Fairy face types are many and varied, but there are some commonly observed elements.

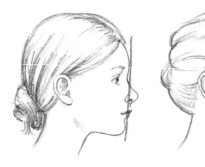

These are naturalistic profiles of a pretty woman and a little girl. Note how the faces are essentially quite flat, and also slope slightly backwards.

I have adjusted the proportions and features to give them a typically elfin look. The differences are not huge, but the effects on the faces are dramatic. The more obvious changes are the larger eyes, arched brows and pointed ears, but just as important are the changes to the face shape.

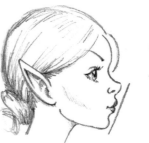
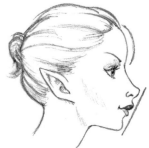

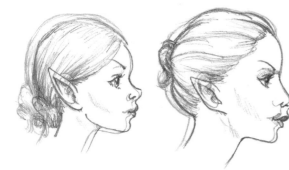

With one face overlaid on the other, you can see the differences clearly. The forehead bulges are exaggerated and the lower halves of the fairy faces protrude forward. The noses may be lengthened or shortened, but an upturned tip is often a good fairy-like touch. It can also be effective to place the ears lower on the head and to slope them backwards. A slender neck is an essential fairy characteristic.

FAIRY FACE
Gallery

Each artist soon develops his or her own style of characterization. It's a good idea to sketch lots of faces and play around with different levels of distortion and caricature. You may find it helpful to base your sketches on photos of real people, or you may prefer to conjure up new characters straight out of your head. Experimenting with different tools and materials will also help you to find your own style.

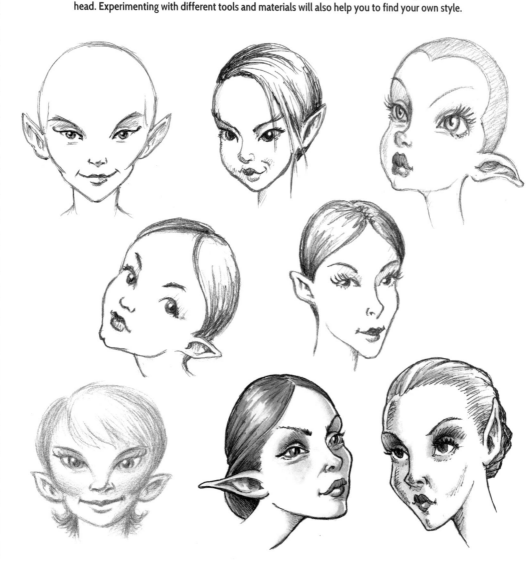

Let's look at creating a fairy face from the more complicated three-quarter angle.

Here's a simple drawing of a human teenage girl. She's pretty, but her features are not very fairy-like, though her face makes a perfectly good starting point.

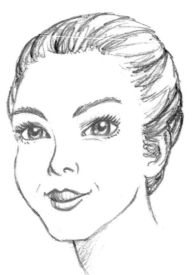

Here I have changed the size of the features. The nose is much reduced and the mouth narrowed. Eyebrows are finer and angled upwards. The eyes are larger (although some artists might make them larger still).

Depending on your own tastes, these kinds of alterations alone may be enough, but there are many more changes we can still apply.

TIP
The shape of the face is very important in establishing character. For example, a solid jawline and thicker neck carry masculine associations. Rounded, chubby cheeks are essential to making very young characters cute. Older characters can be shown with ill-defined jaw lines and sagging jowls.

Changing the shape of the face can make a great difference to the feel of the character. Fairies are often drawn with high cheekbones and small chins, and nearly always with long, slender necks.

To exaggerate further for fairy effect, you can adjust the spacing of the features. Here I have increased the space between the eyes, and further raised the eyebrows. I also lengthened the nose, narrowed the mouth and pushed them both slightly further forward on the face. For a subtle extra touch, I formed the hairline into a bit of a point in the center.

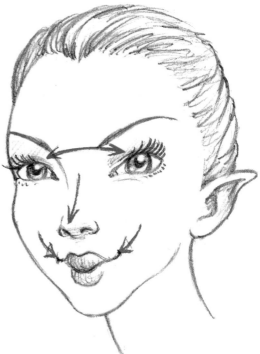

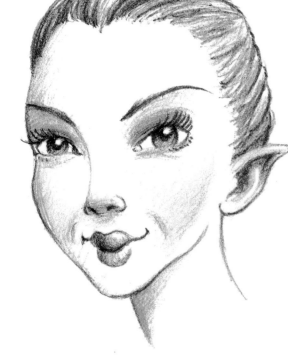

A touch of other-worldly coloring also helps to bring out fairy-like qualities in a character. Here I have used two shades of colored pencil over the partially shaded pencil drawing.

This is only one example of how a fairy face may be constructed. The kind of distortions you use is entirely up to you. You may wish to exaggerate your faces more extremely, or you may want to keep them entirely naturalistic. You're the artist, it's your choice.

Facial Features
EYES

Eyes are a charismatic and characterful part of the fairy face and worth looking at in more detail.

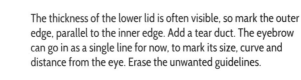

Start with the general shape of the upper eyelid and a circle for the iris. Usually the upper lid slightly covers the iris.

Here are a few examples of eyes that have more of a fairy-like feel, worked in various materials.

Draw a smaller circle for the pupil and, if you want to show a highlight, mark its size and shape. Now draw the lower lid, which will usually touch or cover part of the iris, and the upper part of the upper lid.

The thickness of the lower lid is often visible, so mark the outer edge, parallel to the inner edge. Add a tear duct. The eyebrow can go in as a single line for now, to mark its size, curve and distance from the eye. Erase the unwanted guidelines.

Start shading with an HB pencil, gently hatching the subtle tones of the skin around the eye. Note that eyes facing upwards will need little shading whereas those facing down will need more. The three-dimensional effect created is known as "modeling." With a sharp pencil you should be able to draw fine lines that mimic the individual hairs of the eyebrow.

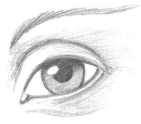

Use a softer pencil to strengthen the tones, particularly in the pupil and the iris. Note that the upper lid casts shade on the eyeball and the iris. A little depth of tone under the eyebrow help avoid it looking too flat.

Once the rest of the eye is complete, use a sharp, soft pencil to add the eyelashes over the top.

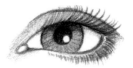

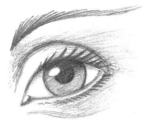

EARS

No study of fairies would be complete without looking at ears. Pointy ears are a universal shortcut to fairy characterization. They are not very different to human ears and may be drawn following the same steps.

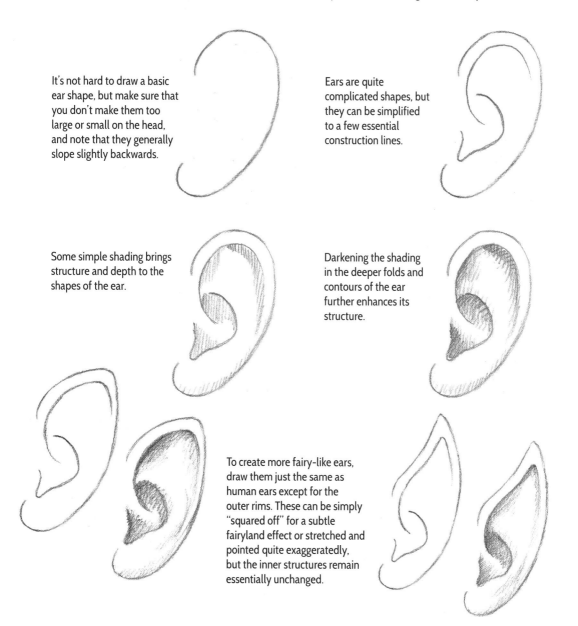

It's not hard to draw a basic ear shape, but make sure that you don't make them too large or small on the head, and note that they generally slope slightly backwards.

Ears are quite complicated shapes, but they can be simplified to a few essential construction lines.

Some simple shading brings structure and depth to the shapes of the ear.

Darkening the shading in the deeper folds and contours of the ear further enhances its structure.

To create more fairy-like ears, draw them just the same as human ears except for the outer rims. These can be simply "squared off" for a subtle fairyland effect or stretched and pointed quite exaggeratedly, but the inner structures remain essentially unchanged.

NOSE AND MOUTH

Other than the cute little upturn that many fairies have, there is little to say about fairies' noses, except that they are usually small and downplayed by the artist. Lips, however, can be greatly varied from thin and thoughtful to luscious and pouting.

To draw the nose and mouth, it may help to think of them as fitting into a triangle; continuing the angles down from the nose gives you the approximate width of the mouth. Consider the distance between the nose and the mouth.

TIP
Note how little of the nostrils you can actually see from a front view. Usually beginners draw them much too prominently. In fact, it's usually a good idea to generally understate fairies' noses. In many fairy drawings noses feature as little more than a stroke of the pencil.

The masses of the nose and lips can be initially drawn as very simple shapes.

Look very carefully at how much of the nostrils you can actually see on a nose that you are drawing.

Add a few descriptive details that bring more form to the features.

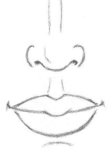

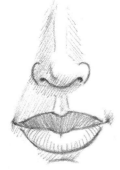

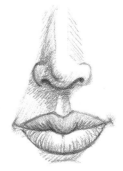

This is a good stage to clean up unwanted marks.

When shading, think of the planes the make up the structures of nose and mouth. The lips, for example look more effective when the shading follows the appropriate directions, angling inwards along the upper lip and curving outwards along the lower lip.

Use a softer pencil to firm up the deeper set parts, between the lips, and around the nostrils. This helps to create an illusion of solidity. Another good trick for a 3D effect is to strengthen the shadow around the very tip of the nose, which brings it forward in space.

For upward-facing planes, such as the upper nose and lower lip, leave the paper white.

LIPS

Lips can vary greatly in size, shape and coloring. Different mouth shapes will tend to provoke different methods of construction and also suggest different colorings and treatments. It's a good idea to practice drawing lips and mouths because they are a very sensual part of the fairy face and convey much individual character.

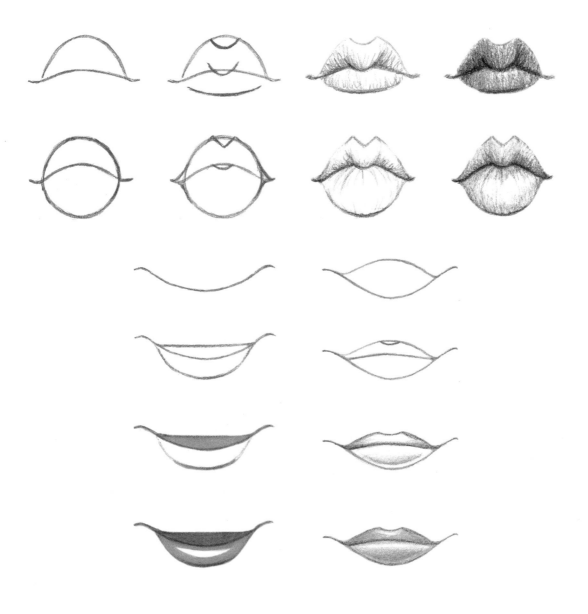

Fairy Hair

No fairy is complete without a head of appropriately styled hair. Some fairy hairstyles can be very long and intricately formed, others may be tightly cropped and boyish, but whatever the style, there are some simple rules that will help you achieve the look you're after.

It's important to recognize that hair has thickness and so should be drawn sitting proud of the skull. It dips in at a parting, in this case a center parting.

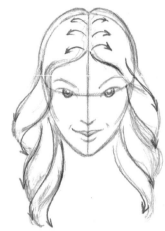

Before getting into any detail, ensure that you are clear about the directions of growth and flow within a hairstyle. In this case, the hair springs up and away from the parting at the top, and also falls away from the sides of the head in gently spiralling curves.

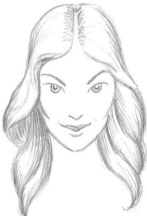

The marks that describe the shading are also good for showing the texture. Always shade in the direction of hair flow. The darker areas are often where the hair meets the head, at the sides or within a parting.

The degree to which you shade and model hair is down to personal taste. You may prefer not to over-work your drawings, or you may like to draw every hair follicle, but in either case, it's usually a good idea to leave a good amount of white paper shining through to show the shine and highlights.

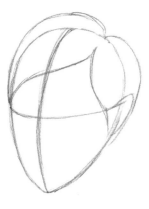

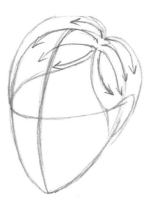

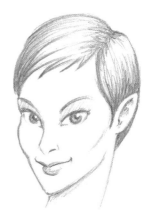

Even very short hair sits proud of the head. In fact, short hair may spring up higher than long hair, having less weight to pull it down.

Short hair also has directions of flow, in this case falling away from the side parting.

When shading hair, it's often helpful to identify a particular direction of light and imagine how it would affect the hairstyle. Here, the light is coming from upper right, so the surfaces facing that direction are left fairly white and the parts angled away are shaded more heavily. The same lighting direction should be used for the face and other parts.

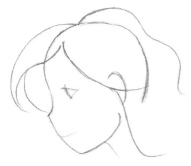

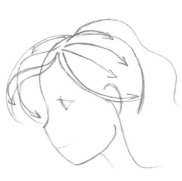

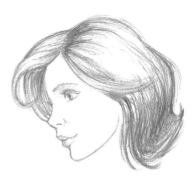

For more voluminous styles, start by drawing the hair as a set of masses. Here there are three masses, each flowing free of the head shape.

Even big and bouncy hairstyles usually fall away from the head at some point. This one features another side parting, and you will note that the lines of flow are very much like those of the short-haired version above.

With heavier shading on the undersides of hair masses, the dark marks help the hair to frame the pale and delicate features of the face.

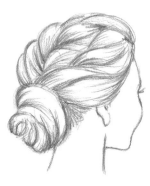
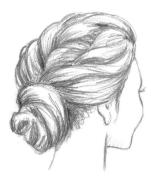

More complicated hairstyles may be composed of a multitude of masses, each of which should be roughly drawn before much shading is applied.

When shading, work on the masses separately to retain the character of the hairstyle.

Reserve the darkest marks for the deeper recesses and folds in the hair, to give those areas greater depth and bring out the three-dimensional, sculpted feel of the style.

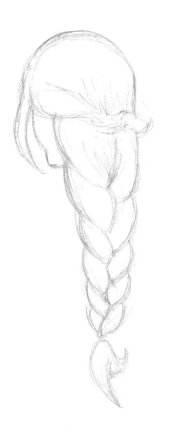
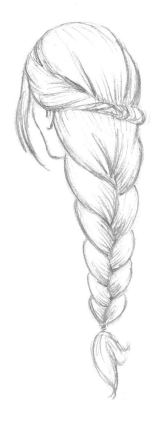
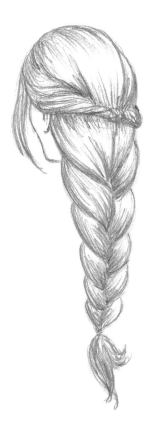

TIP: DRAWING BRAIDS OR PLAITS

Braids or plaits are common features of fairy hairstyles. If you learn how they are structured, you will soon be able to draw them quite easily.

1. Start with the overall shape and then add a center line.

2. Individual braids should be marked as diagonal lines, pointing down towards the center and slightly overlapping the center line. These lines should get closer together as the braid gets narrower.

3. Add scalloped outlines to show the roundedness of each individual braids.

4. With guidelines erased, it should look like a convincing braid.

5. Adding shading to the braids should make them seem to interlock.

FAIRY HAIR
Gallery

Fairy hairstyles can be very diverse and inventive. It can be rewarding and creative to experiment with styles. A few strokes of a pencil are often enough to create a whole new style. Either sketch them out roughly as I have done here, or maybe draw around a template or "croquis," which you can find on pages 28-29.

Practice

Hats, Horns and Headdressess

There are all sorts of adornments available to the fairy head, some of them inspired by nature and others stemming more from human fashions through the ages. Whatever the styles, they will need to be drawn as if they fit convincingly on or around the head.

A wide-brimmed witches'-style hat will offer a good demonstration of how to make a hat fit onto a head. It's important to ensure that the hat sits far enough down on the head. The red line here shows where the hat's headband will sit. Note that the head curves, and so does the fitting of the hat, here tipped slightly backwards. It may help to imagine the shape of the hatband entirely encircling the head and forming an ellipse.

From this angle, we will see the underside of the hat's wide brim. Draw the entire rim as a smooth ellipse, crossing behind the head.

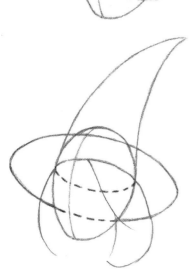

The top of the hat joins at the hatband. Even though the brim will mask this area, draw the hat to ensure that the lines and angles of the hat will work in the final drawing. Hair also should be drawn to emanate from the hatband. It will be held tight to the head by the hat and then freely splay out below.

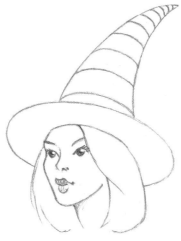

The construction lines mean the drawing will fit together convincingly and the hat appear to envelop the top of the head correctly.

In adding some stripes to this hat, I made the lines increasingly curved as they progress up the hat and further from the eye line of the viewer.

A little shading gives the hat the illusion of curvature. Under most circumstances a wide brim such as this would cast deep shadows over much or all of the face, but you need not draw it so; sometimes you can get away with just a little shading close to the headband.

Whatever the shape or style of hat, it's important to visualize the shape and size of the head inside it. This style of hat fits quite snugly around the back of the head and follows the shape of the skull. The shading on this hat brings out its three-dimensional form, darker around the back and also under the scroll form, and with pronounced curves that follow the forms. A little shading around the face shows the gently snug fit of the hat around the head

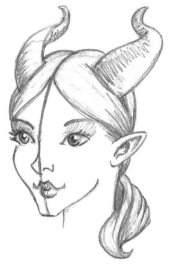

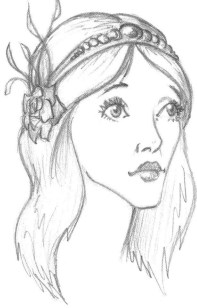

This headband grips the head tightly at the top and back, pulling the hair in toughly and also making the hair splay out from underneath it.

When drawing horns, it is essential that they fit on the head. Just as a vertical center line helps to place the facial features symmetrically, so it helps with the placement of horns. Horns growing up through the top of the head will naturally cause the hair to part around them. Showing the hair tied back can pull it into shape and avoid some awkward-looking hairstyles.

Headbands, head dresses, bows, ribbons, and tiaras are all very popular among the fairy folk. Always ensure that they wrap convincingly around the head and affect the hairstyle appropriately.

Templates

When getting to grips with drawing the complexities of hairstyles, hats, horns, headdresses and so on, it often makes sense to draw the face to see whole head in context. But it can also be quite time-consuming to draw faces, so here are a couple of blank template heads for you to practice on. Trace or photocopy these pages and draw your own designs right on top of them. You can also adapt and rearrange the ears, eyes and other features as you please.

Dotted lines here represent the center lines of the heads and foreheads, to help you to place elements symmetrically and centrally, if you wish. I have also marked the approximate hairline of each head, which may be useful for drawing and creating hairstyles.

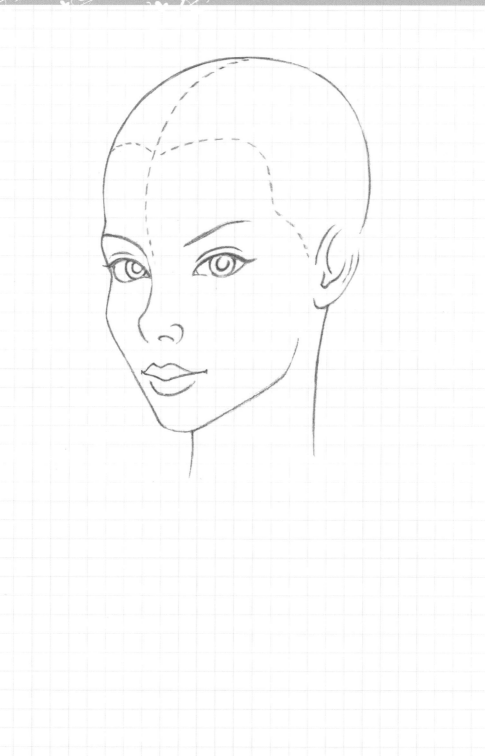

Practice

A Fairy Portrait

Taking all that we have seen so far, let's put it into practice in a fully finished fairy portrait.

Start with the standard upside-down egg shape, leaving plenty of space on the paper for the hair to be drawn in later. I'm posing this portrait with the fairy looking to the left, so the vertical center line needs to be placed to the left and curving to reflect the curve of the head. For the head to be tilted slightly downwards, the horizontal guides sit a little lower on the head and wrap around the shape of the face.

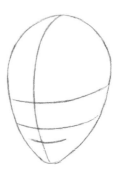

The features can now be roughly mapped onto the framework. I've also added the position of the neck and the hairline.

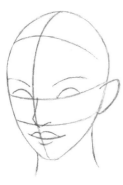

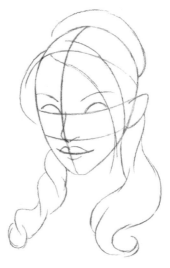

The hair can be merely a set of rough shapes to start with, indicating the general mass and flow of the hairstyle.

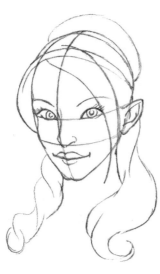

Refine the features to develop more of a distinct character. Don't neglect to pay attention to the outer edge of the face; the contours of brow, cheekbone, and jawline are important factors in a face.

For this portrait I wanted some kind of a headdress so I've drawn its rough shape, curving around the top of the head.

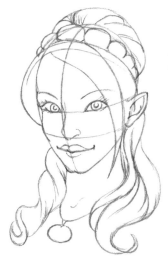

Developing the headdress, I added a series of circular masses around it. I echoed the size and shape with a pendant, to help unify the design of the portrait. At this stage I thought further about how the hair would curl and flow, and added lines to guide me.

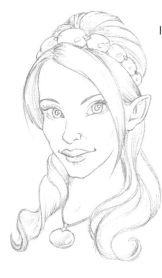

I erased all the redundant guidelines and then spent quite some time working up, polishing and subtly adjusting many aspects of the drawing. I elected to keep the headdress as oval-shaped gems and added highlights on each, as well as highlights in the eyes.

At this stage it would not take too much work to finish this as a pencil drawing, but I chose to work it up as a color design in inks and watercolors.

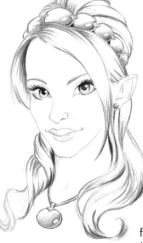

Before starting to color the portrait, I wanted to firm up the outlines and stabilize the drawing. Often the immediate thought may be to reach for black ink for outlines, but there is no rule to say that outlines have to be black and other colors can be more effective. Here I used Prussian blue ink, slightly watered down, with a fine pointed watercolor brush to mark the deepest outlines and darkest details.

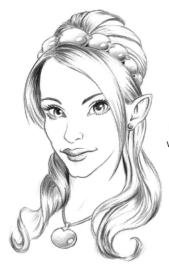

For less pronounced marks in the hair, I elected to switch to a purple ink, for variety and richness. To outline the details of the face I used a diluted dull red ink, which will result in a naturalistic feel.

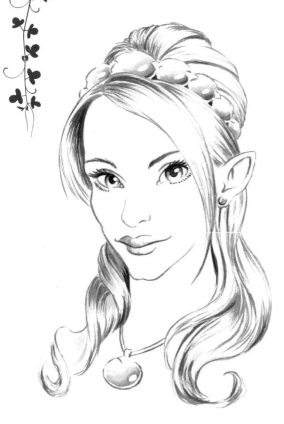

With all the outlines and details quite firmly marked in colored inks, I could erase all the grubby pencil marks. As soon the ink was completely dry, I used a large, soft eraser in broad strokes across the entire surface of the paper, to make it as clean as possible.

The first stage of coloring is shading. Having already established an upper right lighting direction when I drew the highlights in the eyes and gems, I needed to add shading to the face and hair as if lit consistently. I added a little purple into some grey watercolor, quite diluted, and painted it on selected areas with a soft round watercolor brush. With a spare brush, wetted with clean water, I immediately softened the edges of the shaded areas, to avoid making the shading look too harsh.

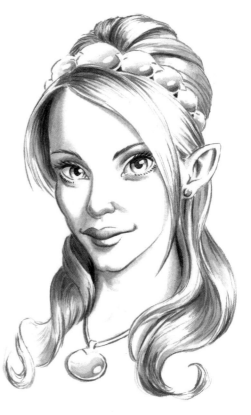

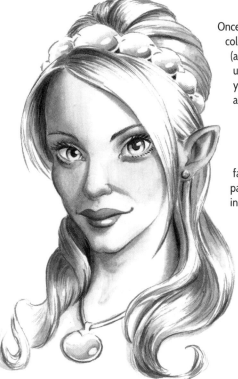

Once the shading layer was completely dry, I could think about color. For this portrait I intended to use naturalistic skin tones (although in the world of fairies any colors are possible). I mixed up a general flesh color using dilute red paint mixed with some yellow and a tiny spot of blue (to keep it from looking too bright and orange).

With some care, but working quickly, I laid some broad washes over parts of the face and immediately softened the edges with a wetted brush. My aim was not to cover the whole face with flesh tone, but to blend out to white for the brightest parts. It is often a really good idea to retain lots of white paper in a watercolor painting; it keeps the work fresh and bright.

I added washes of red to the ear and lips, and a tiny tint in the cheeks.

With the skin tones safely dry, I could then work on the hair, settling on a pinky-purple color. Try to retain plenty of white or very pale areas in the hair for a silky, shiny look. Excess paint can be dabbed off with a paper tower while it's still wet. It may take several layers to building up suitably rich and varied tones in shiny hair.

TIP
Never mix white into watercolor paint; watercolor is a transparent medium through which successive layers of paint remain visible. White makes the paint go opaque and dull. For paler tints simply dilute the paint further so that more of the white paper shows through.

I chose emerald green for the stones and eyes and laid it on in simple flat washes, being careful to leave the highlights untouched. The tonal under-painting and highlights give the stones their depth and surface shine.

TIP
Unless you want colors to merge, wait until one color is dry before working with another, or work on completely separate parts of the painting. To speed up the drying process between layers, a hairdryer works wonders.

For a few tiny finishing details, I turned to white ink. With a very fine-pointed brush I used white ink to reaffirm and neaten up the highlights, not only in the obviously shiny surfaces, but also subtle touches in the ear and nose. The white ink is also useful for cleaning up errant marks around the edges.

For a final flourish, I mixed bright yellow into white ink to touch on some spots of glow into the dark side of the face, as if illuminated by a warm secondary light coming from behind the left-hand side of the head.

Practice

A Graphic Portrait

Once you have mastered the principles of drawing the fairy head you will be free to experiment with different styles of drawing and finishing. Portraits need not be highly finished and richly colored, and sometimes simpler treatments can be more effective and graphically powerful.

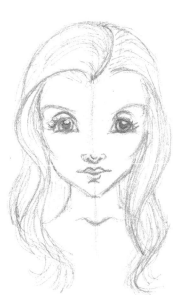

Here I did a quick and quite rough pencil outline. It's a very formal front view, but I decided to break up the symmetry with a side parting and freely falling hair.

With a fine felt-tip pen I drew the main outlines and directional marks for the hair.

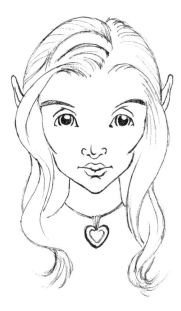

Because ink is stable once dry, I was able to quickly erase all the pencil marks in broad sweeps leaving me a clean outline drawing to work with. I decided to add a heart-shaped pendant to match the face shape.

With the ultimate aim of making this a bold graphic drawing with strong black areas to balance pure white areas, it's not always easy to decide how to arrange areas of black and white, so it's often helpful to work through a 'grey' stage. I have used the same fine felt-tip pen to work out the main tonal and textural areas of the hair, with a few tweaks this drawing could be left at this stage.

Working towards greater simplicity, I started filling in some darker areas, mainly under and around the hair, and firmed up outlines.

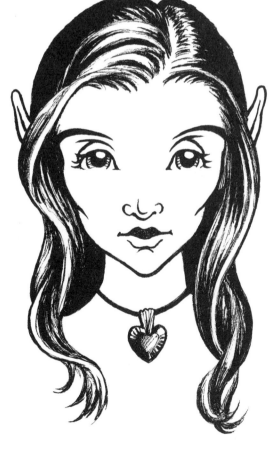

For further graphic impact, I switched to a broad felt-tip pen to block in some solid black areas and to strengthen and refine the outlines. The secret here is to ensure that the edges of the black areas blend with the forms of the hair by following the textural marks and directions of flow. It also pays to refrain from making the black areas too large and overbearing.

A Pastel Portrait

For a quick portrait in pastel, I selected a toned paper, against which white highlights will stand out at the final stage. With a pastel I inscribed the basic shapes of a profile and chose a warm, dark brown, but of course you may prefer other colors.

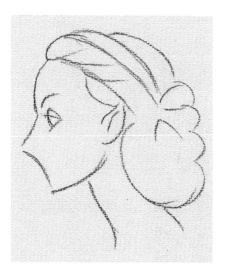

TIP
For pastels, chalks, or charcoal, use proper pastel paper, which has a slightly rough texture or "tooth" to abrade the pastel and allow it to make strong marks over many layers if desired. It can be bought by the sheet in a great range of colors.

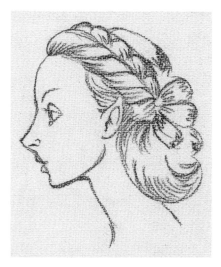

Being very careful not to touch the very smudgeable surface of the drawing, I developed the face and established the main forms of the hair and braids.

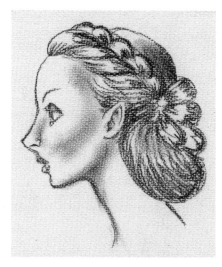

Still using the same pastel, I worked up the textures and tones of the hair, striving to leave the highlights fairly clean. Then, with the side of the pastel, I grazed on a touch of tone to model the face, and softened it by smudging with the tip of a clean finger.

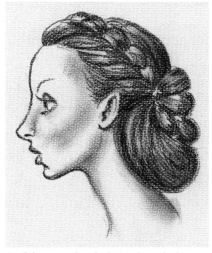

Confident now that the hairstyle worked convincingly, I used the pastel to deepen the shadows and textures. Pastels can produce very deep, rich, satisfying tones.

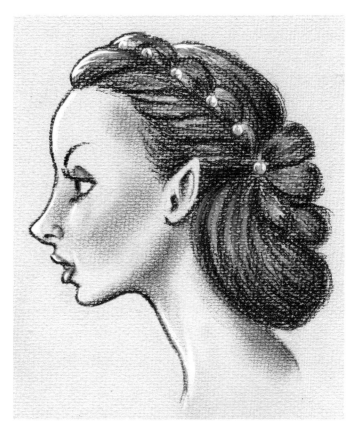

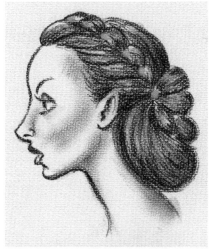

With the pointed corner of a soft eraser, I carefully lifted off some unwanted marks. With black, I reaffirmed some of the darker details, such as in the eye and hair. With pure white pastel I added the final touches of highlights on the pearls and also around the far edges of the face, as if illuminated by a secondary light source.

I strengthened the outlines of the hair here and there, which now looked weak against the deeper tones of the hair. Then I delved into my pastel box and used a dull yellow to bring a touch of color to the hair highlights, and also to draw some pearls woven into the braid.

TIP
Use hair spray on your finished pastel drawings to "fix" them and make them more resistant to accidental smudging.

Practice

Part 2
Fairy Figures
Proportions

Figure drawing is an artist's term for drawing the human body, and most fairy drawings are based very heavily on the human figure. Probably the most important factor in figure drawing is proportion, which is the size of the body parts relative each other.

Child proportions

The standard artist's measure of figure proportions is head lengths. The body's proportions change dramatically over the course of childhood, and the size of the head relative the whole body is a good indicator of age. There is a long tradition of beautiful fairy art based on the naturalistic proportions of human boys and girls, so knowledge of these proportions can be very helpful when doing fairy drawings of children.

At around one year old when a child is typically learning to walk, her body is about the overall height of four of her own heads. By age three, her body will have grown to around five head heights, and by five she will be about six of her own head heights. Growth soon starts to slow down, and it will not be until she reaches ten that her body will be about seven heads tall. Throughout childhood, the proportions of girls and boys are essentially the same.

Of course, the head itself continues to grow throughout the time, but not as much as the body.

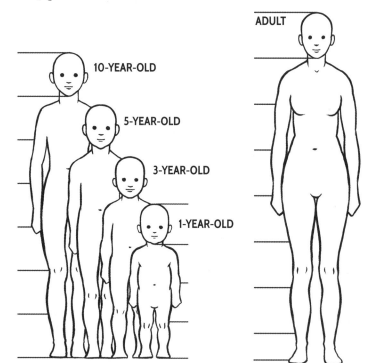

ADULT

10-YEAR-OLD

5-YEAR-OLD

3-YEAR-OLD

1-YEAR-OLD

Adult proportions

Whether male or female, short or tall, by the time a person is fully grown they will be typically around seven and a half of their own heads in height. This diagram represents a fit and healthy young woman of average build. It may be worth studying her general proportions; for example, her legs are about three heads long, and her arms are, perhaps surprisingly, nearly as long as her legs, at around two and a half heads. Note that her shoulders are around two of her head heights in width.

Fairy proportions

Nowadays it is quite standard that the human form is greatly idealized to create fairy art, much like superheroes and other fantasy art. Fairies, though, tend not to be quite so heavily muscled!

Here is a typical kind of figure from the fairy canon, standing at seven and a half heads, like a real person, but differing in many other proportions. Fairies are nearly always drawn very slim with long slender necks and arms. Their legs are generally rather longer than those of a real person, and their upper bodies are reduced to accommodate.

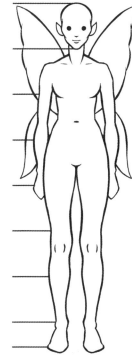

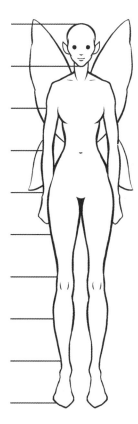

It is not uncommon that fairies are depicted to be slender and elongated in appearance. These figures owe much to the tradition of fashion illustration, for which figures of nine head heights are quite normal. Of course, no real person is constructed in quite such exaggerated proportions, but if drawn well, such figures can appear elegant and suitably fantastical.

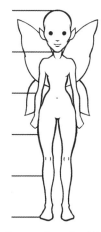

Another popular style of fairy art exaggerates the proportions in a different way. At around five heads tall, such figures have the height of a small child, yet the bodies may be drawn to represent adult figures. Essentially these are teen or adult fairies with over-large heads, and typical of many Disney style characters.

Pose and Posture

Just as fairies tend not to be proportioned quite the same as real people, so their posture and body language is often tweaked and exaggerated for artistic effect.

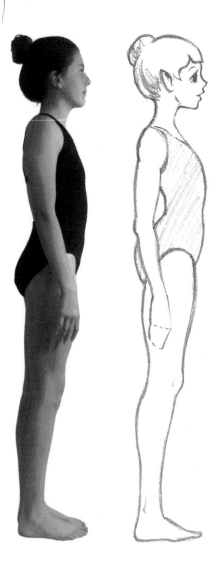

Here's a fit and active girl of around 12 years old demonstrating normal relaxed posture. For the drawing I made a few changes here and there. You will note of course that some of the proportions are altered, but I have also exaggerated the posture. By tipping the shoulders back and angling the ribcage back, the graceful curve of the back is emphasized. This particular exaggeration of posture is very common in fairy illustrations.

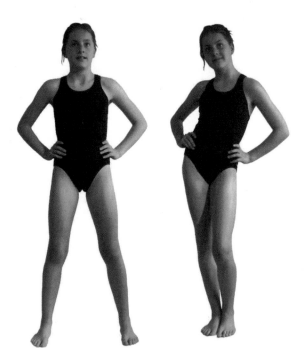

Here's the same model adopting two different poses. Both are standing on two feet, hands on hips, facing the viewer, but how different they are in terms of the attitude they convey. Selecting appropriate poses is an important element of character.

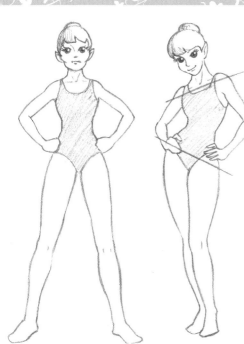

For many artists, the poses in these photographs would be perfectly adequate for fairy characters. However, it may be your preference to emphasize elements of these poses. It's quite easy to do, as long as you are clear about what you intend to achieve.

For the defiant pose, I pushed the feet slightly further apart and tilted them outwards; I made the hands into fists; and I slightly tipped the head upwards. These changes all add up to a more dynamic, action-ready pose.

In sketching the relaxed pose, the main thing I did was to exaggerate the angles of the shoulders and hips. I also tipped the head down a touch, to make the feeling more submissive.

TIP
Layout paper is a good material to use for experimenting with exaggerations. It is semi-transparent, so you can place it on to of photographs and trace them directly, making all sorts of alterations along the way.

You can tell from these very simple diagrams each different kind of feeling or personality. In each case it is the pose that does the work; there are no facial expressions, clothing, props or settings to provide clues to character or intention.

Drawing from a Live Model

If you are lucky enough to have a patient person of the correct build and with spare time to sit for you, make the most of them. It is a great luxury to have a real live person to boss around and dress up and pose for your fairy artworks. It's more likely that if you can persuade anyone to pose, you'll be granted a few minutes to take a few hastily-posed snapshots and have to make up the rest.

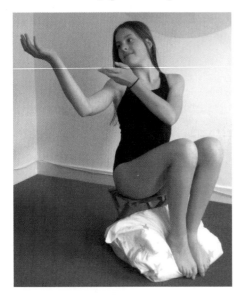

Working from the photograph, I quickly sketched the basic thrusts and masses of the pose. Right from the start I was troubled by the trailing hand, which clumsily interferes with the face, so I moved it down to place it in front of the chest.

This is my daughter reluctantly assuming a fairy-like pose. I sat her on a stool of appropriate height and placed her feet on a rolled-up pillow so that they pointed downwards elegantly. It's quite common to have to improvise with makeshift props and furniture, all of which can easily be omitted for the final artwork. The lighting, costume, hair ,and so on are hardly ideal, but they will suffice.

TIP
If you have a model to work from, allow them to be involved in the posing. They will probably come up with some interesting gestures, and will naturally feel if a pose seems inelegant or strained.

Here I made a few more slight changes to the basic figure; I enlarged the head, narrowed the waist, tilted the legs out, and reduced the size of the feet.

I started to refine the drawing, working on firm outlines and bringing some detail to the head hands and feet. With the corner of an eraser I cleaned up some of the rough marks.

With sharp pencil and eraser, I continued the process of honing the drawing until I had a fairly clean outline drawing, ready to think about clothes and hair.

This may seem like a big leap from the previous stage, but when the under drawing is done well it's really rather quick to add a rough hairstyle and clothes. It helps also that I have chosen here to draw tight fitting garments because they do not need much in the way of folds and drapery. A few wrinkles around the joints are sufficient to convey the idea of cloth.

A small bird at the fingertips and an old tree stump for a seat are suitable props for the pose and character.

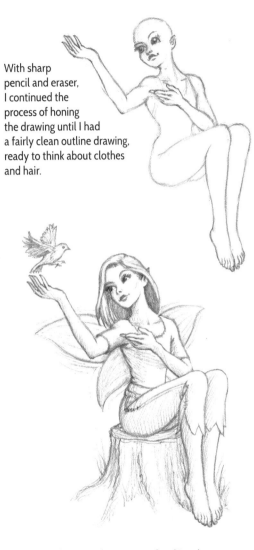

In the end it is simply a matter of making the drawing clean and presentable. I carefully erased all the unwanted pencil marks and smudges, and then reasserted some of the outlines here and there. With some guidance from my reference photograph I also added a little shading: not so much as to make the picture dark and grubby, but just enough to provide a bit of modeling to the three-dimensional forms.

Dynamic Figures

Fairies may be gentle creatures on the whole, but that does not mean that they spend all of their time sitting on toadstools or staring into ponds! To draw more dynamic fairies requires not only a mastery of proportion and gesture as we have seen, but also some understanding of the forces of motion and balance that act upon an active figure.

Lines of action

One of the defining characteristics of fairies is their gracefulness. One of the important factors in achieving grace in the figure is the deployment of lines of action, which are imaginary lines, or more commonly curves, that run through a drawn figure. In this standing pose, for example, there is a clear line running up the trailing leg, through the torso and into the opposite shoulder.

Fairy pictures, aiming always for gracefulness, usually utilize backward leaning lines of action (with typically emphasized arched back), but different actions also call for lines that curve forward.

A more dramatic curve naturally results in a more dynamic figure

This is one of those poses that accentuates the curve of the spine, but the curve extends through the whole figure from the neck to the feet. The drawing is constructed around this line of action.

Lines of balance

Another imaginary line running through a body helps us to visualize a figure's balance. The blue dotted lines on these diagrams are positioned roughly where each body's weight is distributed evenly either side. In most of these examples the line passes through a foot on the floor surface or in the space between two feet on the floor. In such a case the figure clearly appears to be balanced, however precariously. But where the line of balance falls either side of the foot or feet on the floor, that figure will appear to be out of balance. This is not necessarily a bad thing if your desire is to show the figure running, jumping or otherwise moving through space, as in the skipping example here.

High and low viewpoints

Here are two versions of the same figure in the same pose. They look quite distinctly different because each is drawn from a different eye level. In the first the viewer would be around the level of the figure's knees and in the second, slightly above head height. The curves of the head and body, shown here in red, run upwards or downwards accordingly. Learning to show figures from these other perspectives will be very useful for drawing fairies in flying, diving, hovering, and other dynamic poses.

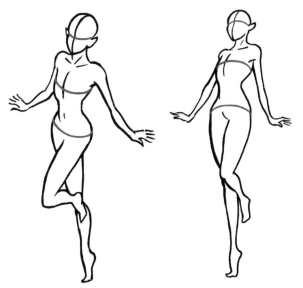

Draughtsman's skeletons

Fantasy and comic book artists often build their dynamic figures around simple skeletons. Such skeletons comprise the essential masses of the figure: the head, chest and pelvis and the spaces between them, as well as all the vital angles and proportions. They are very quick to draw, and allow one to judge the thrusts of a pose before spending too much time on detail.

These skeleton drawings are particularly useful for conceiving and drawing figures in the kinds of dynamic action and/or complicated viewpoints that would be hard or impossible to replicate with live models.

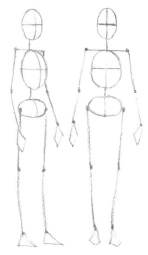

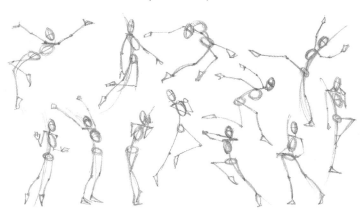

Practice

Creating a Fairy from a Skeleton

Let's put the theory into practice with a demonstration of how you might develop a fairy character from action line and skeleton through to a fully dressed, finished color artwork.

For this demonstration, I have selected one of the skeletons from the previous page to work up into a finished character design. The first stage is to set down a strong line of action.

Around the line of action, I started to construct a skeleton. I thought that the stretched-out pose would suit a very tall, elegant fairy style, so I made the head quite small and left large spaces between the head, ribs, and pelvis.

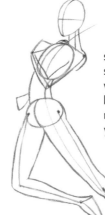

Adding the limbs, I was conscious of their length in order, to maintain a consistently elongated build throughout. I only drew one arm to start with, the other being largely hidden by the body with the pose I had in mind.

Now to add some flesh to the bones. Bear in mind the way that limbs are slimmer at the joints and the muscle swells out between them, even on a very slim body. Note also where the bones are near the surface and the resultant angularity of the outlines. If you're unsure about any of this, adopt similar poses yourself and feel the effects upon your own body.

To support the sense of movement in the figure's pose and balance, I drew the shape of long hair flying backwards and then echoed the wings also trailing behind. A free-flowing skirt would seem to be a good accompaniment, which I drew as a rough shape.

With the basic figure and costume forms in place, it is now a matter of adding further detail and character; the features of the face and hands, further form to the wings and clothing, and I also placed a flower in the fairy's hands.

TIP
At this stage I decided to break up the edges of the skirt in a flower-like frill. Having the confidence to add such textures and details without first drawing them in pencil first saves a lot of time, and helps to maintain momentum and enthusiasm for the piece.

Because there is some small and fine detail involved in this design, I elected to outline the drawing with an artist's drawing pen. The fine tip helps me to outline the detail precisely, and the permanent ink means that subsequent layers of wet paint will not smudge or wash away the lines.

Once the ink line had had a moment to dry, I could erase all the pencil marks quickly and cleanly in broad strokes of the eraser.

Having decided to make the flower a yellow buttercup, I had to consider the shading colors. Greyish tones may be good for general shading, but they are not suitable for bright colors like yellow. Here I used orange, with a little purple mixed in, to paint the shading on the flower and also the skirts and shoulders.

I also painted some touches of red on the cheeks, fingertips, knees, and so on, and then softened their edges with a wet brush. Once the red was dry, I used a purply-grey for some shade on the remaining parts.

Here I added more colors in broad strokes of watercolor, being careful to soften and blend the edges where necessary.

Further layers of color complete the coloring effects I was aiming for; bright, clean colors with some depth and solid form, without being too heavy and overworked. For a few final touches, I used some strokes of white to reassert some highlights.

Practice

Hands and Feet

Sometimes people feel daunted by drawing hands and feet. They are complex structures, but need not be too challenging when we understand some basics of how they are constructed.

Hands

This may look like a reasonably proportioned diagram of a hand, but actually it contains some commonly drawn flaws

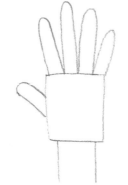

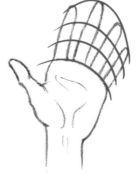

This drawing was based directly on the diagrammatic hand. Further points to note here are the curves–the top of the palm, where the fingers meet, and then increasingly pronounced curves running through each finger joint and the tips of the fingers.

In this version, you can see than the palm sits at an angle relative to the wrist and arm, there is clear space between the fingers, and the thumb angles from the base of the palm. These are all important factors to remember when drawing hands.

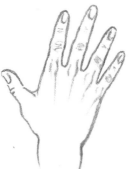

The same structure applies to drawing the back of the hand.

Drawing fairies' hands is all about gracefulness. It is often thought that four extended fingers make for an awkward number and that they look more graceful when not all splayed out, but brought together in groupings such as these.

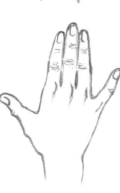

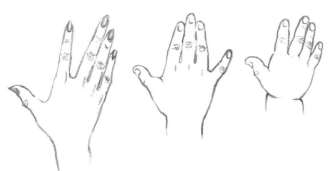

As well as the structure of the hand we need also to consider its styling. Typically, a fairy will have long, slim fingers and possibly some length to the nails, although not too long. If a fairy is not grown up, it will probably suit more child-like hands, which are shorter and less defined in structure. Very young fairies will have podgy babies' hands with fat palms and fingers and deep wrinkles in between, and knuckles that show as little more than indentations.

Another very important factor in creating hands worthy of fairies is their posing. Frequently seen are definite and perhaps exaggerated bending of the wrists, whether it be forwards backwards or even sideways. The little finger may be curled and separated and objects will be held lightly and with the tips of the fingers.

Arriving at satisfying hand poses for fairy artwork can take quite some time, and it may be worth working them out on scrap paper first. Ask a friend or family member to pose their hands for you, or look at your own hands, perhaps using a mirror. Sketch hands often to gain an instinct for the way they work, and for how you can make them look dainty on the page.

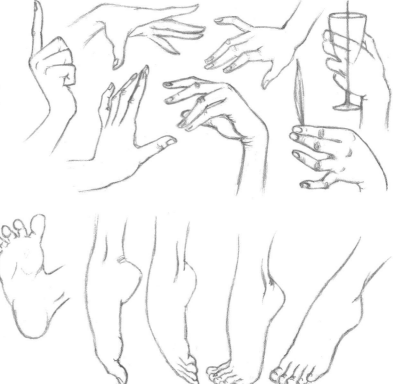

Feet

This is a nice enough foot, but it's unlikely that you would see such a specimen on the end of a fairy's shapely leg, for various reasons: The underside is not a dainty angle of view; the toes are short, a bit chubby and splayed in an ungainly fashion; and the foot is presented at an unbecoming right angle to the leg.

The fairy foot is much like that of the ballerina: long and slender, with the toes bunched together and often curled under the foot. At every opportunity, fairies' feet will point sharply forward, whether they are dipping their toes delicately into a mountain spring, cavorting from toadstool to toadstool, or sitting in a pub on their fifth pint of mead; whether barefoot, be-socked, or wearing magical slippers, straight-angled feet are virtually a golden rule of fairy drawing.

Practice

Part 3
Fairy Fashions
Folds and Wrinkles

Before we look at particular garments, styles, and looks, we need first to grapple with some of the principles underlying how cloth of various weight and cut wraps around and hangs from the body.

Here's an example of close-fitting garments made of stretchy fabric that hugs closely to and follows the shape of the body. But it is not entirely smooth; little wrinkles form from the body's movements, seen here where the waist is slightly compressed on the left. There are tiny wrinkles where the fabric of the shorts has ridden up the legs.

Where the fabric is a little looser the wrinkles are more pronounced, forming deep folds at the waist here. The raising of the arm pulls the fabric up on the right-hand side and away from the hand here, which pins the shirt down at the hip. Where it is not held to the body, the T-shirt is allowed to hang loosely, in this case from the breast.

Under each arm are further wrinkles resulting from where the arms pull the garment out of shape. We can think of these as radiating from anchor points around the armpits.

Anchor points are clear to see with this garment of slightly heavier material. The fabric gathers inside each joint and wrinkles radiate outwards from those anchor points. Here the belt acts as another kind of anchor, from which the fabric is pulled upwards by the raised arm. The skirt by contrast is barely affected by the forces of the upper body and its volume and weight hold its form, with only a few residual wrinkles from prior activity.

Much thicker, looser material produces larger, deeper folds and wrinkles. Even so, they all gather and pull from the same parts of the body and are subject to the same forces. Excess fabric also gathers and bunches, seen here at the wrist and opposite shoulder.

Very loose, voluminous garments may not be affected in the same ways. In this example, it is gravity that has the greatest effect on the hang of the cloth. The loose-fitting pleated arms touch against and hang down from their uppermost fixings (the pleated cuff on the right, the shoulder on the left), and drape over the upper parts of the model's arms.

Likewise, the skirt hangs directly downwards, from the hip on the right and from the hand and buttock on the left, and then is raised slightly by the trailing leg. Note that the pleats are broader in the middle of the drawing and get narrower towards the edges, a perspective observation that helps to create the impression of the skirt wrapping around the solidity of the body.

TIP
To bring a bit of life to clothing you can give suggestions of movement, such as allowing the bottom edges of this long skirt to splay out slightly, which gives it a bit of "swing."

STYLES

The world of fairy fashion has come a long way from the limited range of clothing shown in traditional depictions. Recent generations of artists have adapted the styles of their ages to suit the fairy figure, broadening the realm of fairy fashion. There are still certain kinds of features and stylings that continue to typify fairy design such as in these examples. It may inspire you to adapt these styles to create new designs—or to avoid them completely in favor of greater originality.

Much fairy fashion is derived from historical costume. Medieval and Renaissance style are eternally popular, as well as Victorian, 1920s and styles from ancient history.

TIP
When designing outfits consider the "silhouette," or overall shape made by an outfit, regardless of details. Whether long, thin and figure-hugging; broad and voluminous, smooth or ragged, they should all make for graceful shapes in silhouettes. (Note that fairies' clothes mostly pull in tight at the waist.)

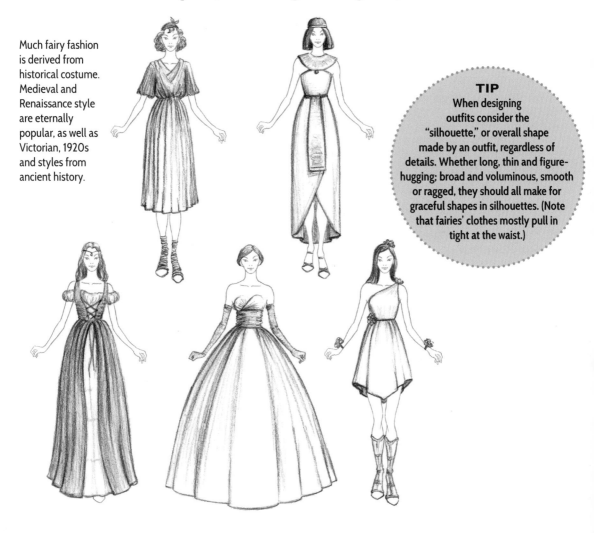

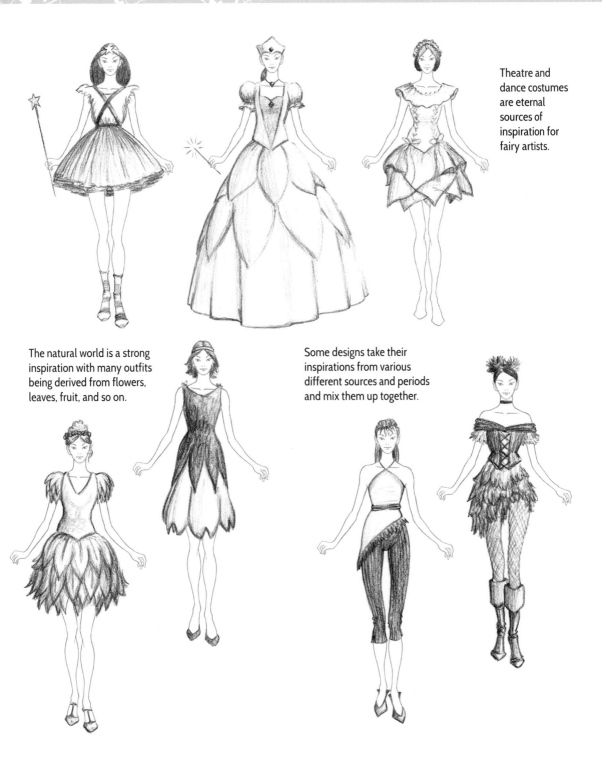

Theatre and dance costumes are eternal sources of inspiration for fairy artists.

The natural world is a strong inspiration with many outfits being derived from flowers, leaves, fruit, and so on.

Some designs take their inspirations from various different sources and periods and mix them up together.

Practice

The Croquis

When designing clothes, fashion designers and illustrators often work on a croquis (pronounced *crok-ee*). This is a kind of pre-drawn template figure, usually in very elongated nine or ten head proportions, on to which the clothing may be sketched. Using a croquis means that your time and effort goes into creating a design, rather than drawing a figure. Here are some examples that you can use to create designs of your own.

Photocopy these pages multiple times and then draw, paint, scribble and scrawl your designs directly onto the croquis.

You may wish to draw your own croquis and perhaps assemble a stock of them in various proportions and poses.

TIP
As an alternative
to drawing on top of
photocopies, you may prefer
to work on layout paper or marker
paper. Placed on top of a blank
croquis drawing, they are thin
enough to see through so that
you can trace new designs
over the top.

Wings

There is no end to the variation in fairy's wing designs. Some come directly from nature, such as bees, butterflies and bats, some are inventive adaptations of natural wing forms, and others are entirely invented by the artist. You can have a lot of fun designing your own, but it may help you to observe some common principles.

Fairies' wings nearly always attach to the body near the top of the back, at or between the shoulder blades. Even when drawn from a front view, the lines of construction all emanate from this area.

From this viewpoint, the wings need to be drawn symmetrically, which is not always easy to get right. It may help to start with only one wing.

Lightly sketch a rough box around the wing and a simple grid within it, then replicate the box on the other side. You may wish to use a ruler, but it need not be too precise, just so long as the two sides look roughly symmetrical.

Within the guidelines it should be quite easy to draw the opposite wing to match.

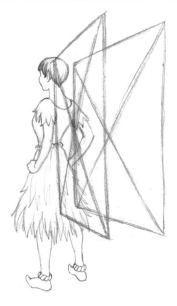

It gets more fiddly if you want to draw a fairy from an angle, where the wings will be seen from differing perspectives, much like the arms in this sketch. Again, you can use the box principle. To start with, imagine your fairy has flat rectangular wings and draw them in place at the size you require. The geometric shapes make it clear to see if the angles are working. Horizontal and vertical guidelines can get confusing when overlapped, so diagonals may be more useful.

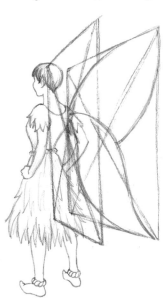

Draw one wing within its box and then replicate the same design within the guidelines of the second box.

When you are happy with the shapes of the wings, erase the guidelines and you should have two matching wing shapes. Within and around those shapes you can then refine the outlines and add patterns and markings.

FAIRY WINGS
Gallery

Here are just a few examples from the huge range of wing styles often used for fairy art.

Butterfly wing

This is a naturalistic wing drawn from a real butterfly and painted with watercolor. I used a very fine pointed brush and diluted brown ink for the outline, and then a broader brush for the blocks of color, blending two shades of brown. The second wing is a graphic interpretation of a butterfly wing using more vivid block color.

Fantasy insect wing

This style of wing is inspired by the dragonfly, though very greatly elaborated in shape, yet simplified in texture. Here I used a black brushpen and a fine-tipped drawing pen.

Dragon bat wing

This wing shape is based loosely on a bat's wing. If it looks a bit like a dragon's wing, that's because dragons' wings are usually based on bats' wings too.

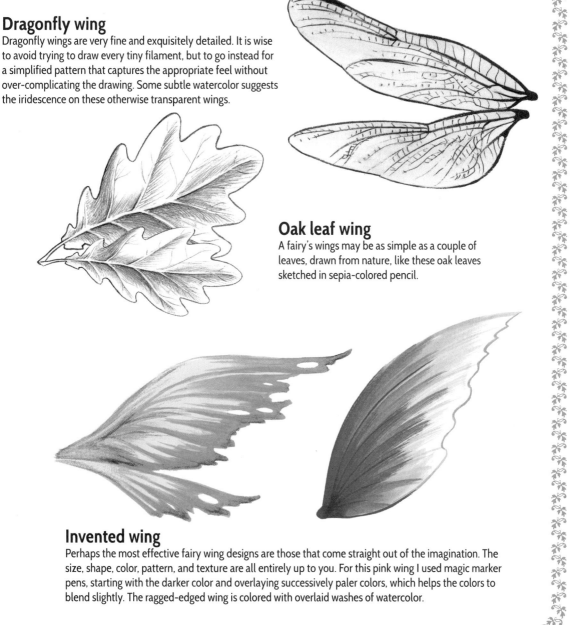

Dragonfly wing

Dragonfly wings are very fine and exquisitely detailed. It is wise to avoid trying to draw every tiny filament, but to go instead for a simplified pattern that captures the appropriate feel without over-complicating the drawing. Some subtle watercolor suggests the iridescence on these otherwise transparent wings.

Oak leaf wing

A fairy's wings may be as simple as a couple of leaves, drawn from nature, like these oak leaves sketched in sepia-colored pencil.

Invented wing

Perhaps the most effective fairy wing designs are those that come straight out of the imagination. The size, shape, color, pattern, and texture are all entirely up to you. For this pink wing I used magic marker pens, starting with the darker color and overlaying successively paler colors, which helps the colors to blend slightly. The ragged-edged wing is colored with overlaid washes of watercolor.

A Fairy Fashion Design

On these pages I shall demonstrate some of the stages appropriate to designing new outfits using a croquis. Here is one of the croquis from pages 70–71 and I have designed a kind of gothic look for this figure.

First, I made a clean copy of the croquis with the figure in the center of the page and plenty of space around to add wings.

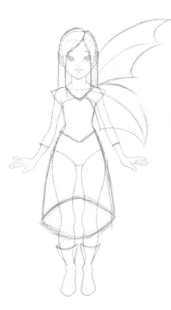

I then mapped out the basic shapes of the garments and wing design. I used a soft pencil, which I find makes me draw more confidently than the tentative marks of a hard pencil. A clean polished look was not important to me here, so much as a fresh and energetic design.

I squared up the wing and drew its mirror image to complete the overall silhouette of the costume. Then I added more detail and structure to the garments.

Some selective erasing and cleaning up, along with a bit more pencil work and I soon had a design I was satisfied with. If at this stage you find yourself displeased with any part of a design, simply erase and redraft it; it's quicker and easier to correct pencil than other materials.

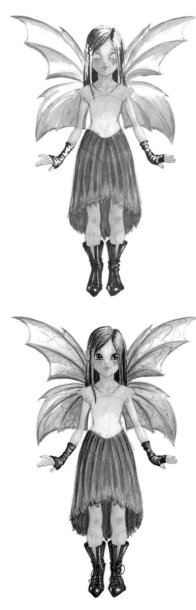

To add some suitably subdued colors, I dug out some old marker pens. Adding flesh colors to visible skin, however crudely, helps you to judge the color and tone of the surrounding garments. Even at this early stage of coloring I was conscious of the different surfaces and textures of the materials making up the outfit.

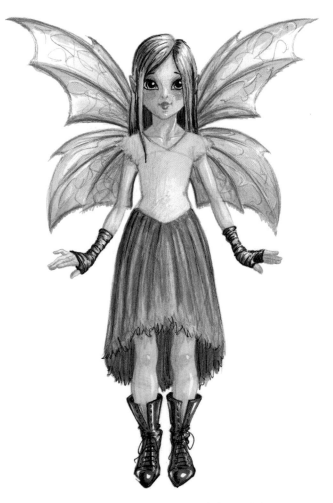

With a fine black drawing pen, I added fine detail to the face and hair, as well as the darker parts like boots and gloves. I then used a soft pencil to add some more bits of shade, and also to introduce a hint of texture in the wings.

For this final stage I used various materials here and there to bring a degree of finish to the drawing, using colored pencils to model and define the exposed skin and to add a little reflective color to the boots. I used more colored pencils in the skirt, as well as white Chinagraph pencil. Swirls of white ink, applied with a fine brush, help to create a feeling of fine filigree detailing and I also used white ink to redefine highlights generally.

Colour

From a few basic building blocks, it is possible to generate millions of colors and infinite combinations of them. Choosing colors and color schemes for your characters' costumes can have a dramatic effect on the mood and connotations of the final artwork, so it is wise to consider color carefully.

Primary colors

There are only three pure colors (otherwise known as hues); red, yellow, and blue, which are known as the primary colors. All other colors are produced out of combinations of primaries, along with black and white.

Tints and shades

When white is added to a color it produces what are known as tints. With the addition of black the colors are called shades. Tints and shades can greatly change the feeling of a base color.

Complementary colors

Each color has its opposite, and placing opposite colors together can be pleasing to the eye, which is why they are known as complementary colors. A color's complement, is made up of the other primary colors it does not itself contain, so red is opposite to yellow and blue, which together make green; orange is opposite to blue, which is not present in orange; and yellow is opposite to purple, made of red and blue.

Monochromatic schemes

An outfit needs not be colored at all to make a dramatic statement. Even so, pure black, white and grey elements can look a very flat in a colored artwork, so mix a tiny bit of color into some of the chosen tones. An effective outfit can be colored using one single hue, in this case, purple. Try to vary the tone in such an outfit, or mix in small amounts of other colors, otherwise the outfit can look inauthentic, just as in real life one can rarely find shirt, skirt, and shoes in precisely the same color.

Away from theory, it's often most effective and satisfying to select colors according to particular themes or pre-existing looks.

Seasons

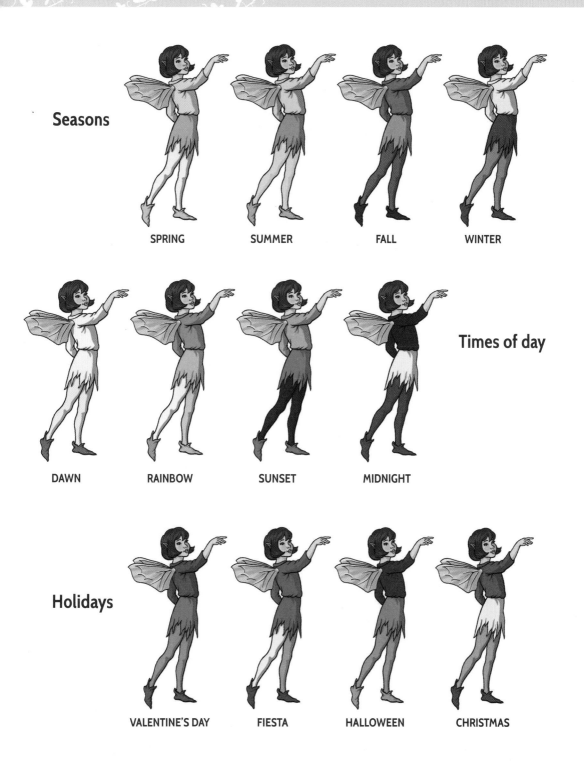

SPRING SUMMER FALL WINTER

Times of day

DAWN RAINBOW SUNSET MIDNIGHT

Holidays

VALENTINE'S DAY FIESTA HALLOWEEN CHRISTMAS

Practice

Part 4
Fairy Folk
Yellow Flower Fairy

Just because most fairies are drawn as skinny that doesn't mean that they all have to be. Here's a demonstration of drawing a more substantial fairy, and then coloring with the vivid hues of poster paints.

Begin with a standard skeleton; in real life, larger people don't actually have larger skeletons. You could make the rib cage and hips a little broader though.

When you come to put flesh on the bones, you can make the belly, buttocks and thighs really quite large before it starts looking too cartoon-like. It is important to note that the hands and feet should not be very chubby, and indeed they may be very fine and delicate, as may the wrists, ankles, knees, and neck.

Having decided to give this fairy a skirt made of petal shapes, I sketched guidelines for the rough form of the skirt.

I drew the forms of the skirt within the guidelines and then drew similar guidelines for some other floral elements on the chest and head. I drew the outline of the face, aiming for rounded cheeks, but still a pretty shape overall.

When you want to paint with bright colors, sometimes it pays to start with a clean drawing. With that in mind I took a fresh sheet of paper and traced the drawing lightly with a hard pencil, which is much quicker and cleaner than trying to erase guidelines.

TIP
If you intend to use wet media like poster paints of watercolors, use a fairly heavyweight paper (at least 160gsm/98lbs) which can take the moisture of paint. Thinner paper will buckle and distort.

For this demonstration, I have used cheap poster paints of the kind used in schools. They come in large bottles, but you don't have to slap lots of paint on to get good results. (The artist's version of poster paint is called "gouache" and can be bought in blocks or sets of small tubes.)

Starting with a clean palette (a white plate will do), I mixed up some clean hues to a fairly wet consistency and laid them on flat and quickly with a soft, pointed watercolor brush.

With the first layer dry, I mixed darker versions of the colors to paint the areas of shade. To keep the colors bright, I did not use any black to darken, but added in color instead: orange into yellow, red into orange, and so on.

TIP
Ensure that one color is dry before painting another adjacent to it, otherwise the colors may bleed together.

This stage demonstrates various ways to soften the transitions between dark and light. For the skin, I stroked a soft damp brush over the two colors to blend them. For the hair, long directional lines mark the boundaries, and I added another darker tone, similarly demarked by directional lines. For the upper part of the dress I have used a texture to blend the transition, with a few dots of the darker hue carried into the paler area.

With a very fine brush I then finished off the little details and some outlining here and there. For the eyes I went for blue, which is the complementary color to orange, and so the two colors make each other look brighter. Some white paint speckled on the dress gives a shimmery sequin effect, and some strokes on the shoes make them look shiny and silky.

TIP
Use a hairdryer to speed up the drying process between stages.

Practice

Elfin Fairy

There is much debate about what elves are and what they look like. Some artists draw them as cute little men or boys in stripy tights helping Santa, others show them as long-limbed and beautiful young women. But all seem to agree that they are simple folk with strong connections to nature and woodland.

I attempted to place my version of an elf somewhere in the middle of the extremes of interpretation; young-looking, though not too childlike, and neither strongly feminine nor masculine.

For a coloring shortcut I decided to do the shading in pencil before using any paint. Having produced a fairly clean outline drawing, I held a soft pencil at a shallow angle to the paper and used the side of the lead to softly apply shading to the elf. Then I used the tip of a finger to selectively soften the edges and transitions. I also used the tip of the pencil to draw some structural markings on the wings.

Elves being creatures of nature, I chose plain earthy colors for the outfit. I mixed up watercolors to the desired colors and consistency and painted them over the top of the pencil shading. Make sure that each area is dry before painting an adjacent area, otherwise the colors will seep into each other. I also added some red for the cheeks and ears and softened the edges with a damp brush.

TIP
If you want to paint over pencil shading, it's best to stick to dark, dull or earthy colors.

When the red was dry, I could paint skin color over the top. Likewise, I added the wing color over the top of the previous detail layer. This is one of the great advantages of watercolor; you can add layer upon layer and previous colors show through.

Another layer of auburn finishes the hair, and then I used selective colors to gently outline and define parts here and there, particularly around the face. Once all was dry I used the corner of a soft eraser to carefully erase any scruffy bits of pencil left around the edges. For a final touch, I added a dash of white chalk to the cheek, to give the skin a bit of glow.

Child Fairy

As you would imagine, fairies begin life as children, and some, it is said, never grow old at all. Here's one such youngster, based on a skeleton of around 4 heads tall. I will demonstrate this in colored pencils, a very common medium and very easy to use.

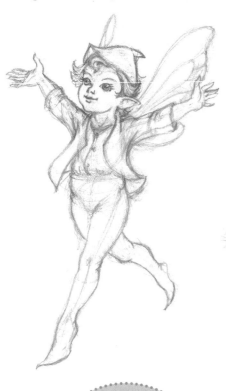

By the time I had finished drawing this character and settled on a pose and costume, it was looking rather scruffy. It would take a long time to clean up all the unwanted marks so I decided to trace a new drawing from this sketch.

I placed a new piece of smooth paper on top of the original and loosely fixed the two together with masking tape. Then I placed the two sheets together on a window pane during daylight hours, and the light coming through revealed the drawing underneath. I used colored pencils to trace the outlines, deciding from the start roughly what colors to use for each part.

TIP
When using colored pencils, it is usually wise to avoid papers with any surface texture. The tiny indentations cannot be reached by the pencils and the artwork will look speckled and lack depth of tone and color.

With the drawing established, I could then move the paper off the window and carry on at a desk. I used the same colors to establish some basic shading and modelling, and introduced a touch of red in the cheeks and lips

At this stage I sharpened my pencils and set about firming up the outlines where necessary. I also drew the fine details of the eyes, buttons and so on, as well as deepening tones and adding more richness to the colors here and there.

One of the features of colored pencils is that they can be blended together quite easily. I continued to color the drawing by introducing different colors on top of the base hues, making the colors more vibrant and varied. Various techniques on display here include graduated colors running up the legs, simple overlaid shading on the jacket, colored lines in the wings, and so on.

Dark Fairy

Just like humans, most fairies are good and kind, but some are not so pure. A dark fairy is not necessarily evil, but will probably be a little less innocent than most. They are sometimes depicted with a touch of the vamp about them, usually in dark or sombre colors. I decided to take advantage of the rich tones of marker pens for this demonstration.

As with any character design, it can take a few attempts to achieve the appropriate look. Here's an earlier stage of this design alongside the costume and wings that I eventually settled on.

Once outlined in ink, I could then erase all the messy pencil lines. I used black felt-tip for most of the outlines but then changed to a pinky-beige marker pen for the skin and wings.

I used a dark grey marker for the more shaded right-hand edges of the dress, and then immediately went over it with a mid-grey marker. Working lighter colors or tones of top of others blends the two together. I also used pale pink for the wings and then richer pink for the hair, taking care to leave highlights.

TIP
Before blending tones and colors on your artwork, it may be wise to practice on scrap paper. Remember it usually works best to use darker tones or richer colors first, and blend over with paler ones.

Pale grey worked over the entire dress blends the tones further, and pale pink worked over the hair produces similar blended gradients.

After adding more dark tone to the dress and blending it in, it only remained to add some touches of detail and texture with a fine-tipped black felt-tip. I also used some white ink to touch out some of the stray marks around the edges. (When working with broad markers it is inevitable that some marks will go over the lines.)

Practice

Goblin

There seems to be broad agreement that goblins are nasty little fairies: green, ugly, usually male, and playfully malicious. Their personal hygiene seems to be somewhat questionable too, so I have chosen to demonstrate this creature with pastels. It's a medium that can be quite grubby to use, but for drawing a dirty, ugly subject that may be quite appropriate.

For the initial skeleton, I was aiming for a slouching, careless posture with slumped shoulders and lazy, hanging limbs. Right from the start I made the hands and feet extra large, to convey this creature's clumsy manner.

Continuing with the same pale green pastel, I added flesh around the bones, with notably skinny arms and a bit of a beer belly. I also marked the size and shape of the big flapping ears and jutting chin. He's going to be gorgeous!

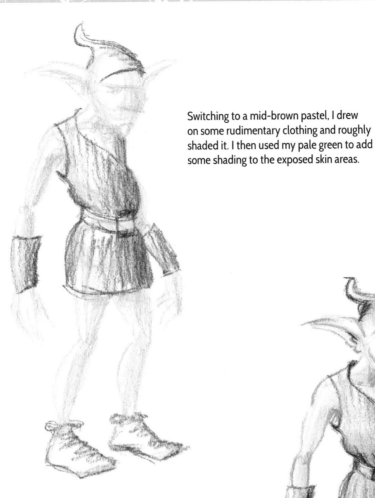

Switching to a mid-brown pastel, I drew on some rudimentary clothing and roughly shaded it. I then used my pale green to add some shading to the exposed skin areas.

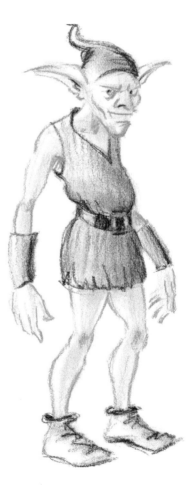

With a fingertip I smudged over the main areas of color and then set about establishing some more detail and character. With a darker green and brown pastels, I drew face and hand details and firmed up the forms of the limbs and garments. I used a touch of orange to give some color to the tips of the nose, ears, and fingers.

After more shading and smudging, the figure is effectively "colored in" and ready for some final firming up of details.

Note how the skeletal under drawing is getting lost within the tones and colors and doesn't need to be erased. It is one of the qualities of pastels that they cover over previous layers–even when working with pale tones on top of darker.

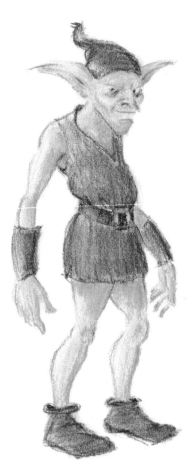

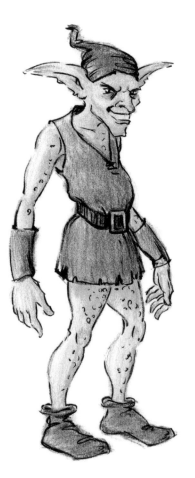

To make the drawing crisper and more defined, I decided to use dark brown ink applied with a fine-pointed brush. Many materials will struggle to make a mark on top of the dusty pastel, but wet ink works well. (If you prefer to keep with the pastel medium, you could use a knife to sharpen some pastel, or perhaps a stick of dark charcoal to a make a good point for drawing fine detail.)

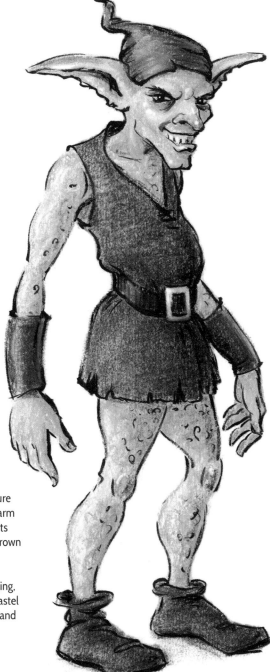

Here I introduced some more colors to add to the depth of shading and modelling. With dark green and blue grey, I worked more character into the face and accentuated the mottled texture of the skin. A little grey or a touch of warm chestnut worked over different garments breaks up the monotony of the same brown used for all.

After a multitude of tweaks and smudging, I used the corner of a pure white soft pastel to touch on a few highlights in the skin and buckle.

Faun

Fauns or satyrs are popular creatures of the fantasy realm. They are usually depicted with the lower body of a goat and the top half of a human, often with horns and other goat-like features of the head. In mythology, they are most commonly male, such as Pan and Bacchus, but there is no reason why you should not draw female fauns.

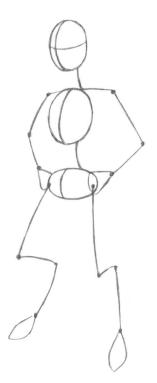

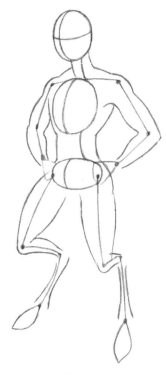

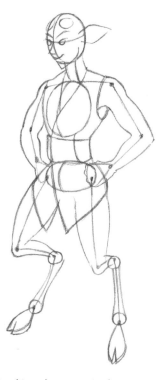

This is going to be a male faun, so the human part of the skeleton has broader shoulders, a bigger rib cage, and smaller hips than a female. The goat legs, like those of nearly all animals, has the same joints as a human, but the proportions and angles differ. Effectively the faun's hooves on which he balances, are like the balls of human feet. The "foot" extends upwards towards a very high ankle. The overall effect is like having an extra section in each leg.

Being male, this specimen is well-muscled and generally broad. The legs, however, taper down to narrow spindles, like those seen in most animals.

To achieve the appropriately knobbly-looking joints of a goat's legs, I marked them with circles, which are broader than the limbs (unlike human joints which are usually narrower). At the opposite end, I marked where the horns will grow from and placed a goatline ear. I decided to give this character a kind of tunic.

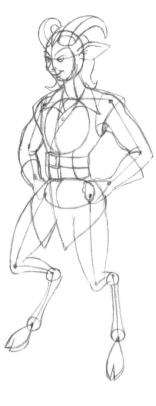

A few more details to the face and
clothing are sufficient for me to take
the drawing on to the next stage.

I used a brown drawing pen to draw
the outline cleanly and then erased
all the pencil marks. Intending to use
water at a later stage, I ensured that
the pen contained waterproof ink.

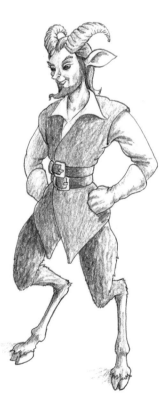

For this demonstration, I used water-soluble colored pencil, which
is a widely available and inexpensive medium. Traditional colored
pencils can be somewhat unsatisfying in their uneven coverage
of the paper, but the water-soluble variety can be used to create
similar effects to water-color. For simplicity, I kept this to a single
color and selected a sepia pencil to shade the character.

With a soft, round watercolor brush I wetted the drawing, turning the pencil marks into paint, which soaks pleasingly into the paper like paint. I worked section by section, starting with the palest areas, and letting them dry a little before progressing to adjoining areas.

Over the top of the dried pigment it is then possible to do it all over again; to use the colored pencil to boost the depths of shading where necessary, and then to blend it in with a wet brush. Of course, you could also choose to change pencils and work other colors over the top of your base layer.

TIP
When wetting the pencil marks, you can sponge off excess pigment with a dry tissue, or a clean soft brush.

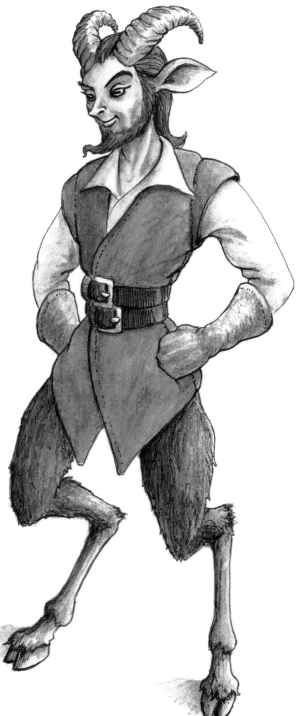

Once the pigment had completely dried,
I then returned to the brown drawing pen
to restate some outline and added some
extra depths of shading and texture.

Practice

Part 5
Fairy Flora and Fauna
Integrating figures

Now that we have learned about how to draw fairies, it is only natural that we should turn to drawing their environments and all the many living things that comprise them. But first we must consider some of the ways in which we might integrate an imaginary being into the natural world.

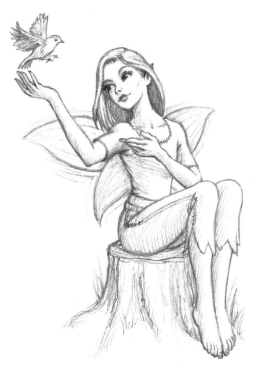

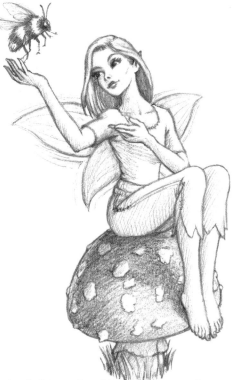

Scale
Looking again at this earlier drawing, familiarity with birds and tree stumps gives us all the necessary clues to understanding that this fairy is intended to be about the same size as a young human.

Leaving the fairy unaltered, I changed the secondary elements and immediately the fairy appears to be very much smaller. The scales at which our fairy characters are perceived are entirely relative to their surroundings.

Interaction

It is clear not only that this fairy and owl are about the same size, but that they also belong together as a unified picture. They are both rendered in the same drawing style and both illuminated from the same lighting direction; but more that this there is an interaction between the two characters, the fairy pointing out something in the owl's book, and the owl's expression revealing his reaction to this interaction.

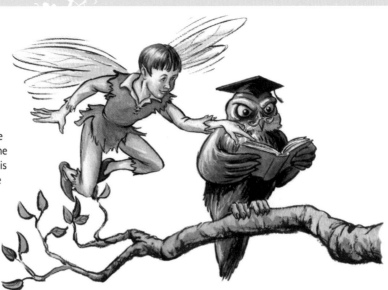

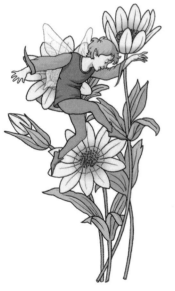

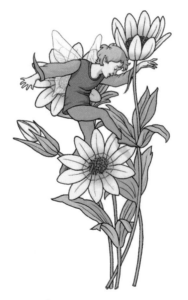

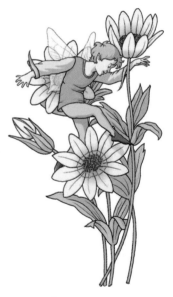

Backdrop

Here the fairy is obviously part of the picture with the flowers being set so firmly against them, and also having them visible through the translucent wings. But there is little integration between the fairy and flowers and no clues as to how close the two elements are intended to be to each other.

Overlapping

With the simple device of overlapping parts of the fairy with parts of the plant, the fairy is clearly sited in among the flowers and belonging in their world.

Assimilation

The fairy can be further integrated into the flowers by coloring it in the same kind of color palette. This way it appears as if it belongs among these flowers, in the same way that animals in the real world are adapted by camouflage to their surroundings.

Flowers

An integral part of the traditional fairy's world, flowers are incredibly varied in their sizes and colors, but perhaps the greatest variety is to be observed in their forms. Yet there are certain basic groups of shapes into which most flowers fit, and learning the basic drawing procedures for these shapes will help you to draw most kinds of flowers and also other organic forms.

Circular

There are many types of star-shaped flowers with petals numbering from four or five up to twenty or more. However complex they may be, they can generally be drawn within circular guidelines, which allows for the even placement and sizing of the petals.

Spherical

A complicated flower like a rose can be thought of as generally round (although some may be more flattened in form, like a bread roll). Within the general shape, once the center is identified further petals can be drawn around it, gaining dramatically in size with distance from the center.

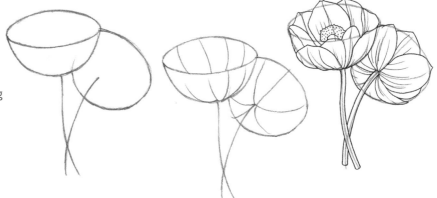

Cup-shaped

Cup or bowl-shaped flowers, however ragged their edges may be, should begin as simple cup shapes. Identifying and marking the general directions of their petals' growth will bring immediate solidity to these forms, and help enormously when drawing individual petals.

Trumpet-shaped

Trumpet or bell-shaped blooms can be thought of as star-shaped or circular flowers with extra depth and form. Note that these examples are seen from an angle, and so their circular guidelines are drawn as ellipses.

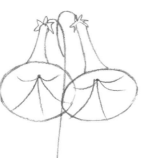
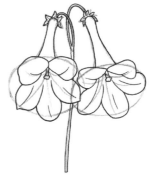

Clusters

Where flowers are clustered together like these foxgloves, the essential thing is to map out the basic sizes, shapes and positions of the flowers. Although such groupings may seem complex, they become more approachable when considered as individual flowers. Bear in mind that you need not be extremely accurate with such subjects, because no-one will ever compare your drawings with any actual example.

Small Creatures

We may think that we know what animals look like, but recognising them is not the same as drawing them. In most cases they are more sophisticated than we may assume. Let's look at some of the little beasts that are typically found in the fairy kingdom.

Insects

The dazzling colors and patterns of butterflies and dragonflies make them popular inspirations for fairy artists, either as themselves alongside fairies or as parts of fairy design, most commonly the wings. Diverse though these species may seem, they have many common characteristics that they also share with bees, ladybirds, and every other insect.

All insects' bodies comprise three sections, the head, the abdomen and the thorax. In all cases, all the wings and the legs are connected to the middle section, the abdomen. Insects usually have four wings and always have six legs. For the sake of clarity, I am showing only the two wings and three legs of one side. There is a generally triangular shape to the wings from this angle of view. It is often helpful to observe underlying geometric forms when drawing animals.

Compared to the butterfly, a dragonfly's head is much larger and its other body parts greatly elongated. The wings are of an entirely different shape and alignment. To help capture the symmetry of the wings, use a geometrical perspective box, like those demonstrated for fairy wings on page 73. In any final rendering ensure that you use finer and more delicate marks for the wings than for the comparatively solid body.

A simple diagrammatic sketch of a mouse skeleton will demonstrate that there is more to these charming creatures than a ball of fluff with ears and a tail. Underneath their fluffy exterior is a frame that resembles a T. Rex. In fact, nearly all animals from frogs to eagles, or humans have essentially the same parts and joints in their skeletons; the differences are mostly only in the proportions.

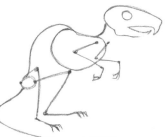

It is always helpful to bear underlying anatomy in mind when drawing any creature, because it helps to spot subtle changes of contour, and also to make sense of potentially confusing articulation. Even so, when it comes to drawing a fluffy friend like a mouse, we can think initially in terms of simple shapes. At the first stage you need only to set down the main masses of head and body and their relative sizes and positions. With the proportions and posture established, more details can be gradually added. A few small ruffles in the final outline help to convey a furry texture.

TIP
Whatever creatures you wish to draw, you would be well advised to seek out a good selection of reference photographs, rather than work from a single source. Looking at multiple angles and poses will help you to build up an understanding for an animal's characteristic features and behaviors.

The same principles apply to a different creature, such as this little bird. Start with the bulk shapes of the head and body, add lesser masses such as the tail, wing, and leg guidelines, and only when you have a strong overall form should you add the fine details of feathers and claws.

Practice

A Fairy Companion

You should have all the tools in place now to attempt fully integrated artwork with interactive elements and a background setting. Keeping the background simple for now, I'll demonstrate drawing and painting a fairy seen against the sky, along with a bit of wildlife.

Having found a good reference photo, I started by roughly mapping out the basic shapes of the bird. Satisfied with its proportions, I drafted a figure in skeleton form sitting on its back, being careful to position it so as not to obstruct the wings. Much of this skeleton will not be seen in the final artwork, but drawing the entire figure helps me to see that it works anatomically. With reference to another photo, I drafted the sprig of rowan berries, making sure that it overlapped the fairy, which helps to integrate the two elements.

With frequent reference to my photos I started to add flesh to the bones and to develop the characters of bird and fairy.

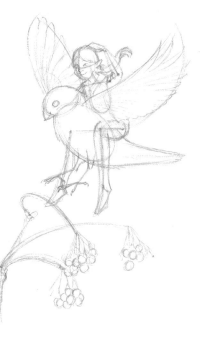

After some more drawing and roughly erasing some of the redundant guidelines, I arrived at a reasonably finished drawing. By dint of my berries photo being leafless and wintery, I decided to run with that theme and to dress the fairy accordingly, hence her wooly hat and furry boots.

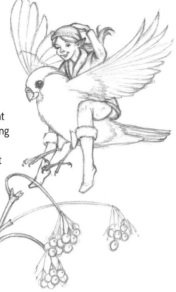

Intending to use watercolors at the next stage, I copied the picture onto heavyweight paper, fixing the drawing on a window in daylight and tracing the image through with waterproof drawing pens.

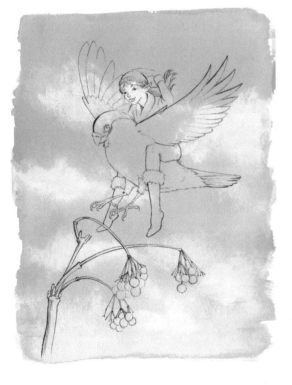

TIP
It is well worth practicing painting flat washes and clouds on spare paper before you commit to a finished artwork. If you produce good ones, you can always trace fairies onto them once they are dry.

It is tricky to try to paint sky around all the shapes of the bird and branches, and would probably lead to a patchy finish. It is easier to paint across the entire picture area. In preparation, I fixed the paper to a board, prepared a rich wash of Prussian blue watercolor, and armed myself with clean tissue paper. Using a broad, soft brush, I wet the paper all over and then loaded the brush with paint. I angled the board at about 45 degrees. In smooth strokes, left to right, I applied the blue.

Working down the page, gravity makes each stroke run into the next and the paint should form a smooth surface. Before it dries, take a clean tissue and dab where you want the clouds to be. The tissue lifts the pigment cleanly off the page.

Once the blue was dry, and being very careful not to go over the lines on to the bright new sky, I painted the main colors for all the parts of the painting. You will notice that they look very dull here, because of the blue showing through.

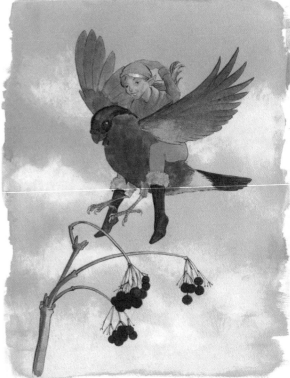

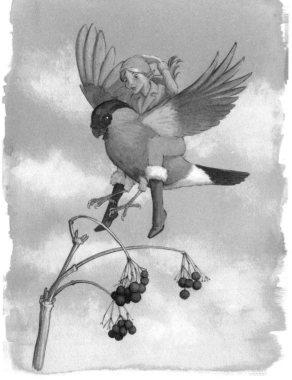

For this next stage, I mixed white poster paint into my watercolors. This is known as "bodycolor" and it makes the paint opaque. In this way, we can cover over the dullness of the under layers and make the painting brighter and more colorful.

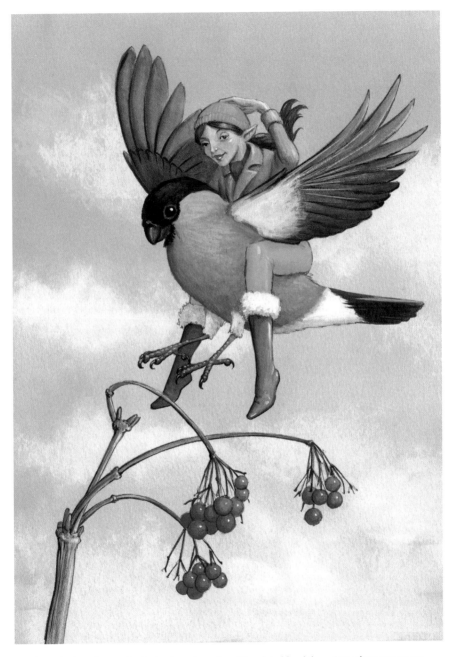

Over the base layers of painting I used a soft wet brush to blend the paints where necessary. I also strengthened the colors and tones in places, using transparent and opaque paints as necessary. I firmed up some of the outlining with the drawing pens and also used tiny spots of white paint to make highlights on the shiny parts, such as the berries and claws.

A Fairy of the Forest

Perhaps precise and careful drawing and mark-making are not your natural style. Just because fairies are delicate and pretty, that doesn't mean that all fairy art has to be delicate. If you are at heart a scruffy worker like me, you may enjoy a more freeform approach, like the following demonstration.

TIP
Looking at compositional sketches from a distance, in a mirror, or upside-down will help you to see them as abstract, and therefore to judge the pictorial balance without being confused by the subject.

I started with the vague idea of setting a fairy in a forest and selected a brown, water-soluble pencil. Working on fairly heavyweight paper, I started with an action line and then built a very rough skeleton around it. Around that I quickly sketched in some very rough marks to indicate where background items might work well.

I quickly built up more of the figure and surrounding features. I was not concerned with any detail or styling, but looking to establish a balanced composition.

I used the side of the pencil to roughly shade in the main areas of darkness.

With a fairly broad brush, I painted water over the dark areas of the picture. The water dissolves the pigment in the water-soluble pencil and turns to paint, which you can push around with the point of a brush.

I started to add some color using dilute watercolor and broad strokes. Keen to keep the face clean, I wet it with clean water and dabbed the pigment off with a clean tissue.

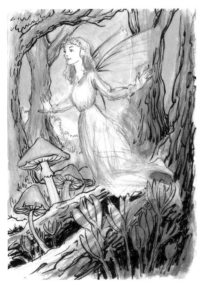

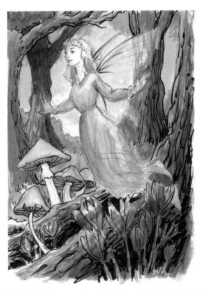

Sensing it was time to pin down some detail, I drew only the base painting with fine drawing pens, brush and sepia ink. Making marks in the distance thin and pale, and those in the foreground dark and solid, creates a sense of depth in the picture. For the foreground pink crocuses, I used purple ink.

With further washes of watercolor I filled in the remaining patches of color. I elected to make the fairy's dress the same color as the flowers.

I used more watercolor to enrich the colors and tones and set down some more detail in the wings and dress using purple ink and a fine brush.

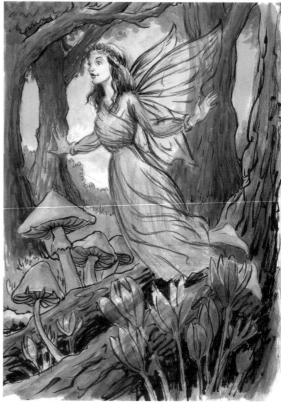

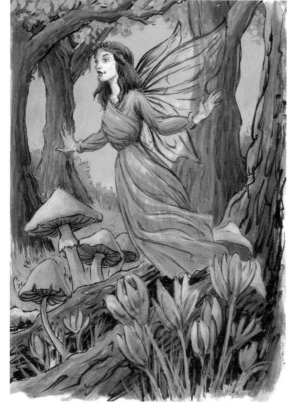

For the next stage I started mixing white into the paint to give it opacity. I painted a flat tone across the sky and also adjusted some of the tones in the background trees. Working towards the "front" of the picture I used opaque pink to color the flowers and make them stand out pale against dark.

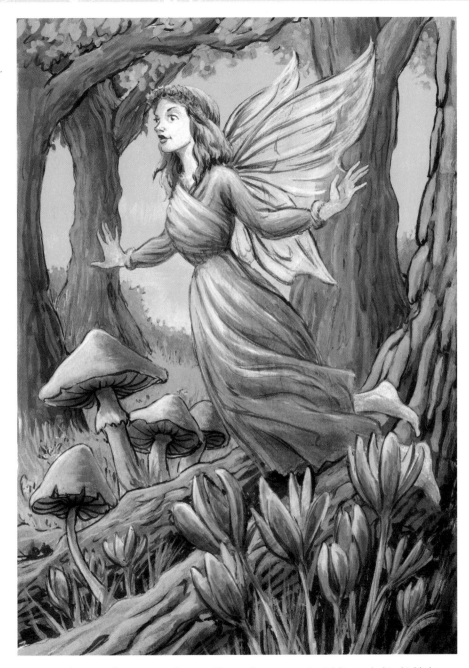

Using a combination of transparent glazes and line work, opaque paint, ink line and white highlights, I tweaked the picture here and there to bring it to completion. I could have continued to fiddle and make the picture more polished, but I rather liked the loose feel. There comes a time when we have to set the brushes down, say "that's enough," and move on to the next artwork.

A Fairy and a Fish

If you favour a simpler, less fussy approach to coloring, you could try working in the more linear, graphic style of ink outline. This medium was popular in vintage fairy illustrations of the late 19th and early 20th century, and involved traditional flexible metal drawing pens that are dipped into ink. Such pens, though old-fashioned, are still available cheaply in art shops and can produce effective and satisfying results.

Having decided to a subject, I found some pictures of water lilies and also a young woman in a suitable kneeling pose. I began by mapping out the basic skeleton and the sizes and shapes of the flowers and leaves.

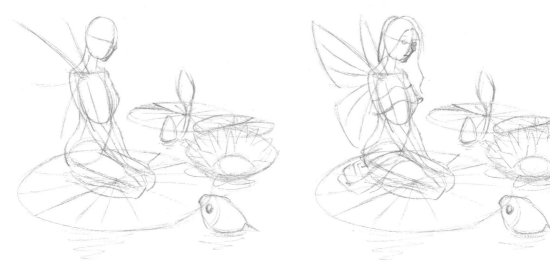

I added flesh to the bones and details to the plants, and went on to set down the shapes of a dress, hairstyle, and wings.

As I worked up further detail with a sharper pencil, I roughly erased most of the guidelines to leave a reasonably finished, if scruffy, line drawing.

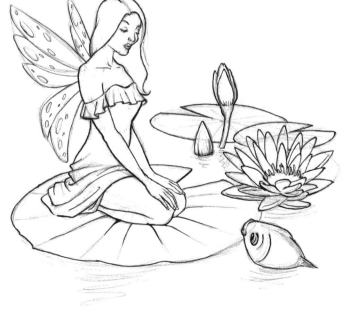

TIP
Before using a dip pen on a drawing, it may be worth spending a bit of time practicing the strokes and getting comfortable with the feel of the pen. Use scrap paper to draw a range of different kinds of marks: squiggles, straight lines, wavy lines, zig-zags, circles, and so on.

Once satisfied with the pencil drawing, I could start the ink work. I dipped the pen into black ink and then tested the mark on a piece of spare paper before starting at the top left-hand corner. The ink remains wet for a long time, so it's important not to smudge over the wet lines with your hand. Be prepared to spin the drawing around to gain access to parts that may be hard to reach. When you have a simple outline, set the drawing aside to dry thoroughly.

When the ink was dry I thoroughly erased all the pen lines, then set about a second stage of inking to bring more life and sophistication to the drawing. The drawing pen has a flexible nib, which if pressed down hard will produce a thicker line. In this way, I could make some lines heavier to indicate the fall of light and shadow.

I also drew some rippled reflections on the water surface. Solid areas of black I painted in with brush and ink.

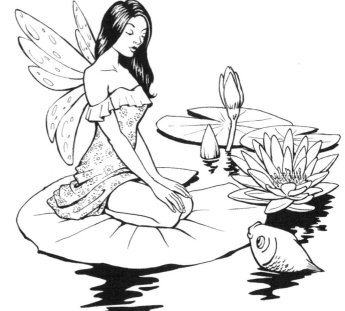

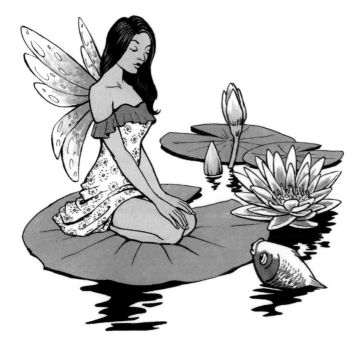

With relatively sophisticated line work and establishing a sense of solidity and lighting to the drawing, the coloring is freed from performing those duties and can be more purely descriptive of color and decoration. You could use any transparent medium such as colored pencils and felt-tips to "color in" a line drawing. I chose watercolors and mixed bright, pure colors to put down quickly and simply. Some parts I laid down as flat, pure colors across broad areas, while other parts I expected to paint over again with color once the original colour had dried.

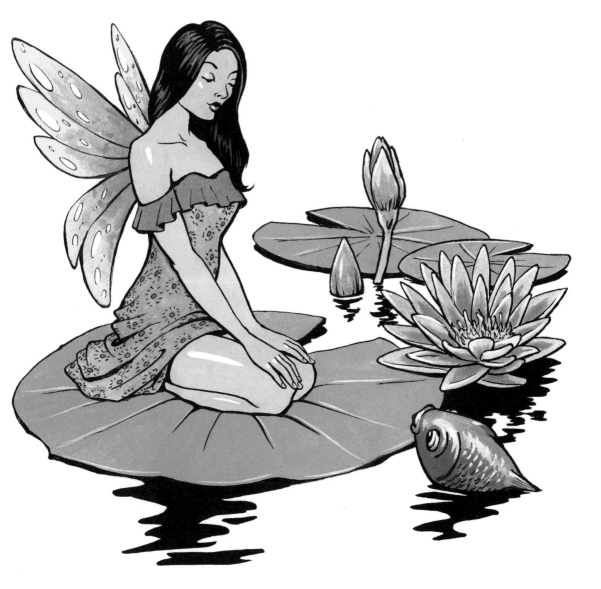

Once the first layer of color was dry I could apply further layers of color. Having spent some time on the outline work, it could be tempting to add more layers of color and shading, but that would risk the colors becoming overwrought and losing brightness. I merely added a few minimal strokes of white ink for finishing highlights.

Practice

Practice